professional
MODEL PORTFOLIOS

A Step-by-Step Guide for Photographers

BILLY PEGRAM

Amherst Media, Inc. ■ Buffalo, NY

In memory of Billy M. Pegram, Sr.

ACKNOWLEDGMENTS

Special thanks to Loa Andersen for her contribution with the text portion of this book (see pages 112–20).

MODELS—Andra Ohman (Seattle, WA), Laine Gabel (Saskatoon, SK, Canada), Jenna Phillips (Monterey, CA)

MAKEUP AND HAIR—Jessica Phinney, Wade Wolcott, Tracy Lewis

AGENTS AND AGENCIES—Loa Andersen, Tom Gusway, Dan Grant, and Cody Garden. For more on these talented individuals, see page 91.

Copyright © 2004 by Billy Pegram
All rights reserved.
All photographs by the author unless otherwise noted.

Published by:
Amherst Media, Inc.
P.O. Box 586
Buffalo, N.Y. 14226
Fax: 716-874-4508
www.AmherstMedia.com

Publisher: Craig Alesse
Senior Editor/Production Manager: Michelle Perkins
Assistant Editor: Barbara A. Lynch-Johnt

ISBN: 1-58428-137-5
Library of Congress Card Catalog Number: 2003112493

Printed in Korea.
10 9 8 7 6 5 4 3 2 1

No part of this publication may be reproduced, stored, or transmitted in any form or by any means, electronic, mechanical, photocopied, recorded or otherwise, without prior written consent from the publisher.

Notice of Disclaimer: The information contained in this book is based on the author's experience and opinions. The author and publisher will not be held liable for the use or misuse of the information in this book.

Table of Contents

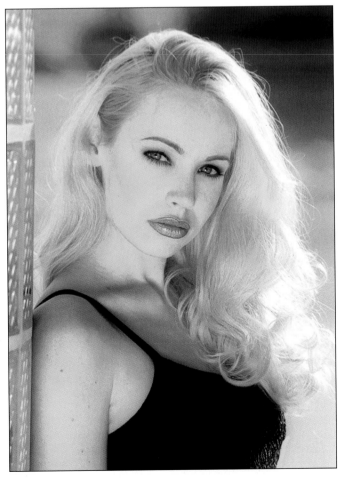

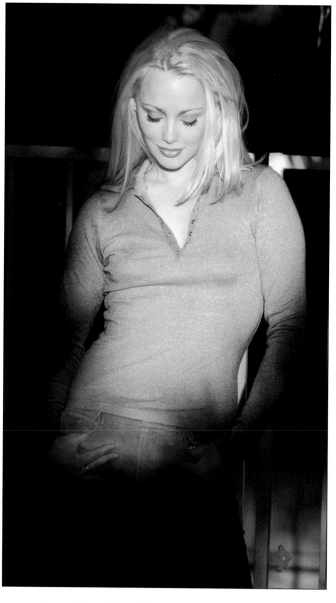

7. LAINE'S PORTFOLIO74

Laine has the height needed to work in the U.S. or European markets. Therefore, we created a portfolio with a wide variety of images designed to help her find representation in these markets. In this section, you'll find the complete portfolio, followed by information on how each image was created.

8. JENNA'S PORTFOLIO83

Jenna was sixteen when we created this portfolio, so she only wanted to work locally. Therefore, we created a portfolio that featured commercial images designed to help her find modeling work in this market. In this section, you'll find the complete portfolio, followed by information on how each image was created.

9. FREQUENTLY ASKED QUESTIONS . . .91

Models and photographers who are new to the industry often have lots of questions about how it works. Here, you'll find answers to some of the most commonly asked questions.

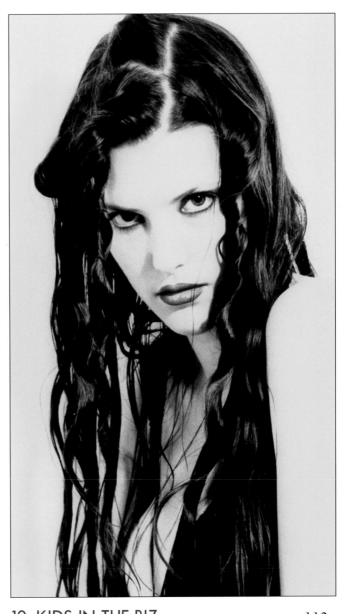

10. KIDS IN THE BIZ112

Over the years, modeling consultant and former agent Loa Andersen has helped lots of children get work in the modeling business. Here, she shares her insights on what she looks for in child models and in their photographs.

IN CLOSING .121

INDEX .122

Introduction

When I started out in photography, I wanted to be a landscape photographer. However, with subjects that change very little from year to year and the need to build an extensive stock collection before you begin receiving compensation for your efforts, I soon decided to take my career in another direction.

I decided to start shooting fashion, model, and talent photography because there is a constant influx of new people and creative ideas in that field. Fashion and model photography allows you to work either with a client/model separately or with a group of other creative people, like makeup artists, designers, location specialists, and agents. Their goal is to create a powerful visual experience; the still image. In addition to providing ample avenues for creativity, you are paid at the time of delivery.

As a model photographer, it's your job to create images that will stimulate the viewer of the portfolio to hire the model.

As a fashion photographer you are a problem solver. Your job is to show the clothing or product in the most appealing way. You must create a mood to make the client's product sell to a potential viewer. When shooting for a model's portfolio, that same idea applies, but the model herself is the product. The same procedures and thought processes also apply, but now to making the model appeal to the portfolio's potential viewers.

How do you show the model's best attributes? Creativity. As a model photographer, it's your job to create images that will stimulate the viewer of the portfolio to hire the model. To succeed, you need to possess the precise technical skills of the commercial photographer, the creative eye of an artist, and the sensitivity to the human condition of the fine-art portrait photographer.

◼ THE CHALLENGES OF MODEL PHOTOGRAPHY

Technical Changes. No matter how experienced you are as a photographer, there are always new techniques to learn—new equipment, new film and capture methods, and new styles. Your repertoire of techniques must always be changing and suited to the current tastes of the market.

What to Emphasize. An additional challenge in working in fashion is that you need to be versed in all aspects of hair, makeup, and photo styling. Building a team of specialists is crucial in attaining professional status as a shooter. This involves carefully evaluating the purpose of each session. Before I do a fashion shoot, I ask myself some questions: What are we trying to show? Is it a particular item of clothing, something special about the clothing (e.g., a zipper, material, or a design)? What is it that will prompt the viewer of the photos to want to purchase this product?

When you are shooting images for a model's portfolio, you should ask yourself the same questions. What are we trying to show? What will inspire the client to hire this model? Remember, the purpose of creating the model's portfolio is to show a wide range of looks and to feature her best attributes. The ultimate goal is for the potential client to see something in her book that he can relate to and, based on that, to want to hire her.

Remember, teamwork counts. After you decide what you need to emphasize in the photograph, your team (makeup artist, hairdresser, and photo stylist) will all need to work together to create the optimal image. Having specialists assist you drastically reduces your workload and adds to the creative process. A good support team that works together frequently can even help

Some images in a model's portfolio should show prospective clients how she can represent a product—here the playful knitwear.

an advanced amateur photographer begin to produce top-quality professional work.

Working with People. Fashion photography is not just about recording an image, it's about making a statement. When you are working with professional models, it is their responsibility to bring forth the desired feeling in the photograph. Professionals know how to pose their bodies to complement the important elements of the photograph, whether it's clothing, jewelry, or another product.

When working with beginners, however, it is absolutely necessary for the photographer to give the new model specific and concise direction. Be patient during the shoot, because new models will experience frustration in posing and communicating the feeling that is required. This makes providing positive statements and reinforcement a necessity.

The model must feel at ease to do her best work. The photographer's responsibility is to create a safe and comfortable environment and to assist the beginner with understanding the shooting process.

■ THE REWARDS
OF MODEL PHOTOGRAPHY

Creativity. The rewards of model photography are immeasurable, because it is a creative occupation where you are involved in every phase of the process—from the concept to the completion. Creativity is encouraged and rewarded, and you are also given the opportunity to work with many other creative individuals.

Travel. Also, as a model and fashion photographer, you will be given the opportunity to travel and experience new environments—not

In model photography, creativity is encouraged and rewarded, and you are given the opportunity to work with many other creative individuals.

Instilling confidence in a new model is one of the most rewarding parts of the business of model photography.

as a tourist, but as an integral part of the region. The fashion photographer will get a unique impression of the location because he will integrate the landscape and the "feel" of the area in his fashion work.

Financial. Financially, this field can be very rewarding, but it may take years to become known or to establish a distinctive style and a great reputation. Marketing your distinctive style and reputation will, however, create a demand for your work and thusly reward you with financial success and elevate your work status.

Making a Positive Change. On a personal note, the aspect of this field that satisfies me the most is the ability to instill confidence in a new

model. Many young models lack self-esteem. They are convinced that models who are published are perfect and lacking any personal flaws. The driving force for me to continue working with beginners is to see the expressions on their faces as they view their photographs and see that they look like the established models they see in print. The change in self-esteem and confidence that appears as a portfolio progresses, and the praise of the parents about the change in their daughter's life, is, to me, an immeasurable reward. How do you put a value on a positive change in someone's life?

■ BEGIN WITH PORTRAITURE

In this business, it takes a long time to get established, so be prepared to go the distance if you want to achieve success. You will also need a great deal of photographic knowledge to prepare yourself for all the demands of lighting, posing, etc. You'll need to become knowledgeable about makeup, hair, and clothing styles, plus you'll have to learn to work with and instruct people. All this knowledge needs to be gained before starting out as a fashion photographer. If you start shooting as a fashion photographer before you have gained the expertise needed you can easily blow an assignment and establish a poor reputation.

My recommendation for getting started is that you begin as a portrait photographer, where you practice your skills in a controlled lighting environment and learn to develop a rapport with people. In fact, the images of many fine portrait photographers cross over into what is really more of a fashion or commercial style, because their clients want "designer portraits"—portraits that are creative and unique to the individual.

Using lighting, composition, and design, each photographer—whether portrait or fashion—will create their own style. The portrait specialist, however, can use the same style, or combination of styles, for many sessions—or even for years. This can be a great asset when you are getting started, since it allows you to become comfortable with the photography process and working with your subjects without the constant pressure to produce a totally unique image every time.

Fashion photographers, on the other hand, must constantly change their style. Many fashion specialists may have shooting tendencies (e.g., use of grainy film, bright colors, tilting the camera off axis, etc.), but they must be able to adapt quickly to each client's needs or they will eliminate many potential accounts. This versatility of photography is what allows the fashion business to rapidly change and go into entirely different directions. The general public, the buyers of the products being sold, has a short attention span and is always looking for innovation in fashion. As a result of this fast pace, the fashion industry justly rewards those photographers whose creativity and ability to innovate can keep pace with the changes in this always-evolving field.

The successful fashion or model photographer must be able to adapt quickly to new styles in order to meet the needs of each client.

As you become comfortable with the process of creating portraits, it is therefore important that you begin to challenge yourself to design and execute self-projects that will teach you additional lighting techniques and fashion styles.

Develop your own style slowly, and don't accept clients or jobs you are not totally comfortable in handling. As you progress, you can develop a team of hairdressers, makeup artists, and clothing stylists to give you the best possible chance of creating great images.

As far as the business aspects go, it's a full-time job to maintain the books and deal with the paying of bills and banking, so I turn that aspect over to someone I can trust. This frees me up to do what I do best—shoot.

As you progress, there will be times when your business is up and times when it's down, times when your individual style is hot, and times when it's not in high demand—but that is also part of the fun! You'll find that you are inspired to keep changing and growing in order to meet the demands of the market.

■ ABOUT THIS BOOK

The first chapters of this book provide you with an overview of the processes used to create a successful model portfolio—a portfolio that a model can use to market herself and receive a contract from a major modeling agency. Then, you'll see three sample portfolios and read about each image, learning how the portfolio as a whole was carefully sculpted to reveal the unique characteristics and ability of each model, and to get her into the market that is best suited to her look. Finally, you'll learn about the next steps in a model's career, so you'll be prepared to answer a model's questions about finding an agent and getting work. Also included are tips for children entering the modeling business.

You'll find that you are inspired to keep changing and growing in order to meet the demands of the market.

1. Getting Started

Most photographers have had this experience: a girl is in your studio having her school pictures taken and mentions that she would like to become a model. "How do I start?" she asks. "Can you help me?" What is your reply? What steps are involved in helping her realize her dreams?

■ CRITERIA

The first step in helping a potential model embark upon a career is to mentally evaluate her general potential. There are three major criteria that you need to keep in mind: age, height, and overall appearance.

Age. The model's age will help you to determine whether her portfolio should be directed toward a local, regional, or international market. Generally, models under sixteen are limited to local and regional modeling because of school requirements, work restrictions, a need for chaperones, etc. While it is true that international agents—especially in Japan—take younger models, this is the exception rather than the rule.

The model's age will help you to determine whether her portfolio should be directed toward a local, regional, or international market.

Models who are over twenty-one also tend to be limited to local and regional work, as it is difficult for a beginning model who is over twenty-one to start a career with a high-fashion agency. Most major agencies are hesitant to invest the time, effort, and money in a model who has a "limited shelf life." This is harsh, but true. Of course, there are commercial and talent-oriented markets in which over-twenty-one models are considered very desirable (a "talent" is someone who specializes in acting roles, such as in television commercials or as a spokesmodel for a particular company). Be prepared to offer these market possibilities as an alternative for the prospective model who happens to be a bit older.

Height. Height is critical. Shorter models are limited to more commercially oriented work and speciality modeling, such as hand work, fit (a model that designers hire to fit clothing on during the design process), lingerie, swimwear, hair, and beauty (modeling where the products [such as makeup, jewelry, or hair care products] require facial beauty). Taller models have a much broader market. After carefully evaluating the chart below, you can determine the marketing target for your client.

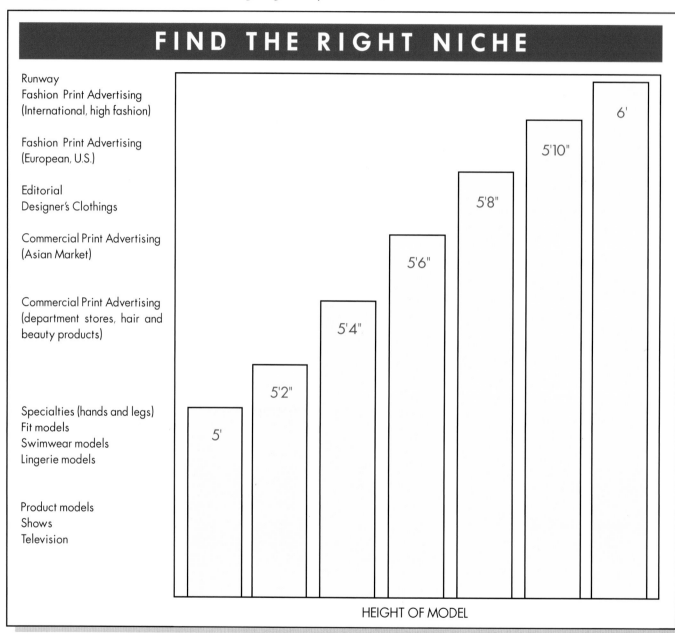

FIND THE RIGHT NICHE

Runway
Fashion Print Advertising
(International, high fashion)

Fashion Print Advertising
(European, U.S.)

Editorial
Designer's Clothings

Commercial Print Advertising
(Asian Market)

Commercial Print Advertising
(department stores, hair and
beauty products)

Specialties (hands and legs)
Fit models
Swimwear models
Lingerie models

Product models
Shows
Television

6'
5'10"
5'8"
5'6"
5'4"
5'2"
5'

HEIGHT OF MODEL

Keep in mind that these are only guidelines—generally accepted standards. If a model doesn't fit in the category she wants to work in, a great portfolio and a lot of determination can still help to make it happen.

General Appearance. Here your own personal "eye" will determine whether or not it is worthwhile to work with the potential model. Styles

and preferred looks change as often as hemlines. What was unacceptable two years ago is in demand now. It is the photographer's responsibility to keep up on the current "look." However, clean skin, straight teeth, and a good bone structure are always in fashion.

Once you have evaluated these criteria to your satisfaction, you are prepared to answer her question—"Yes, I *can* assist you."

■ PROFILE SHEET

Preliminary Profile Shots. Next, arrange to shoot the profile shots as per the examples that begin below and continue through page 17. These are critical to the development of the model for several reasons:

1. They serve to focus the model's attention on areas of her appearance that need improvement.

2. As an accurate before and after record, they provide a record of the model's development.

3. They help to convince the model (and her parents) that modeling is a business for which potential and beginning models must seriously plan, prepare, and work if they are to achieve success.

I will generally have the model provide her own film for this shoot, then take the film for processing (having two copies made of each frame). Then she returns to the studio with the prints for the consultation. How quickly and efficiently she does this will give the photographer an

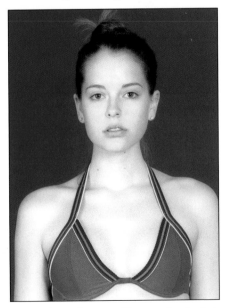

The profile shots begin with simple images of the model with her hair down with a normal expression and a smiling one. The next shot is similar, but with the model's hair up (she can smile or not).

indication of her commitment and determination.

For the model's profile sheet, the photos are taken without makeup. We use this profile sheet along with the goal sheet to help in the development of beginning models. We have found the sheets help in many different ways.

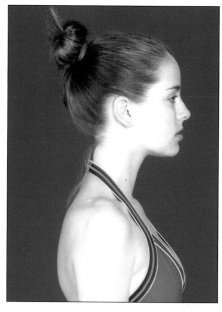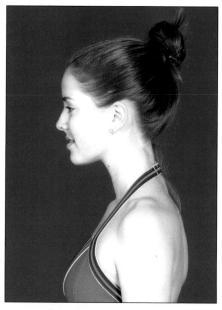

1. Helps a beginner realize that this is a business and that there are many things she needs to consider besides physical beauty.

2. Helps a beginner visualize how she looks and what changes need to be made in order to start working on her portfolio. She may need to evaluate her body and modify her figure to fit particular clothing or styles. For example, if she wants to model swimwear, she may need to reduce her waist from 27" to 24". For athletic wear, she might need to tone up her thighs. She might need to put herself on a good skin care program. Realistic body changes—ones that can be made in a healthful manner—will increase the possibility that a model will have a successful career.

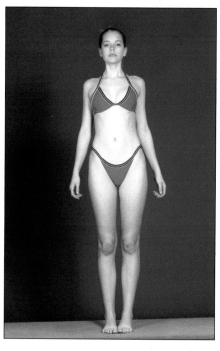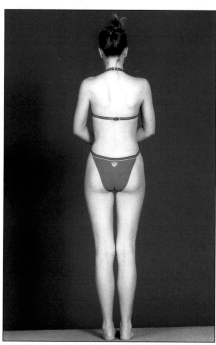

Also included in the profile shots are right and left profiles of the model's face. Here, just the photos with the model's hair up are shown, both hair-up and hair-down versions are normally done. Then, the front and back of the model's body are photographed full length.

3. Gives a visual reference for the studio's hair consultant so he can write a prescription that the model will take to her stylist in order to achieve optimal hair condition. New models frequently need a new color, or intermediate coloring as their roots grow out. Also, a new cut may provide the model with more versatile styles or better flatter her face. Models need a good maintenance program to prevent dryness or to correct

damage that has already been done to their hair. A good hairstylist can help the model get the maximum versatility out of her hairstyle and establish a good hair maintenance program.

4. Gives a visual reference that the model can take with her to her personal trainer for an exercise program to optimize her appearance.

The profile shots show the model wearing a two-piece bathing suit and in a simple standing pose with her arms down. They cover her from

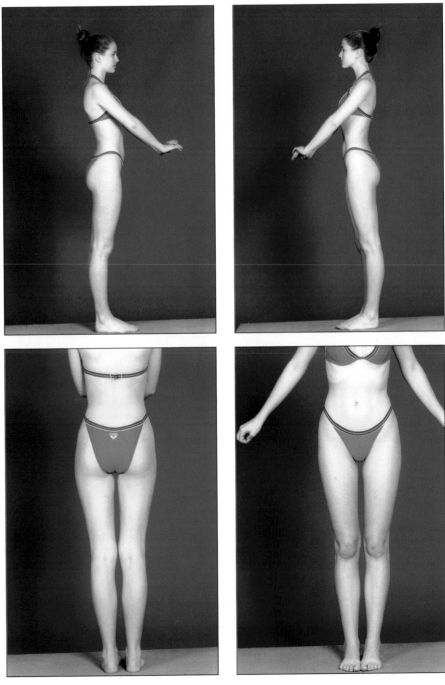

Continuing with the full-body poses, the model is photographed in profile (left and right), then front and back images of the legs, from the waist to the floor, are created.

all angles and with a few variations in her facial expression and hairstyle. On the previous three pages, you've seen a basic set of profile shots, but here's a list that you can refer to when shooting your own:

1. Hair down, no smile
2. Hair down, smile
3. Hair up, smile or no smile
4. Right profile, hair down
5. Left profile, hair down
6. Right profile, hair up
7. Left profile, hair up
8. Full body front, hair up
9. Full body back, hair up
10. Full body, right profile
11. Full body, left profile
12. Close up of any scars or tattoos
13. Legs, front view, waist to floor
14. Legs, back view, waist to floor

A versatile hairstyle works best for most models.

Statistics. A completed profile sheet should also include the model's statistics and measurements, as well as the date on which the photos were taken. The needed information is as follows:

1. Date of Birth
2. Height
3. Weight
4. Hair color
5. Eye color
6. Bust (include cup size—i.e., "34B")
7. Waist measurement
8. Hips measurement
9. Thigh measurement
10. Ankle measurement
11. Wrist measurement
12. Shoe size
13. Date of photos

How to Take Measurements. When taking measurements for the model's profile sheets, use the following standards for taking women's measurements:

Height—This should be measured in inches and listed in either inches or in feet and inches. Measure to the nearest half inch.

STATISTICS SHEET

Date: _____

MODEL'S NAME:

Date of Birth: _____

Height: _____

Weight: _____

Hair Color: _____

Eye Color: _____

Bust/Cup Size: _____

Waist: _____

Hips: _____

Thighs: _____

Wrist: _____

Shoe: _____

PROFILE SHOTS:

Head Shots
- ❏ Hair down, no smile
- ❏ Hair down, smile
- ❏ Hair up, smile or no smile
- ❏ Right profile, hair down
- ❏ Left profile, hair down
- ❏ Right profile, hair up
- ❏ Left profile, hair up

Body Shots
- ❏ Full body front, hair up
- ❏ Full body back, hair up
- ❏ Full body, right profile
- ❏ Full body, left profile

Close-ups
- ❏ Close up of any scars or tattoos
- ❏ Legs, front view, waist to floor
- ❏ Legs, back view, waist to floor

Extras

- ❏ _____

- ❏ _____

- ❏ _____

- ❏ _____

Weight—This should be measured to the nearest whole pound. However, weight is not as important as it once was; it lost some of its importance when models began to gain muscle mass but still maintained great body proportions. As a result, most agencies no longer list weight on their models' cards.

Bust—The model should wear a normal bra (not a push-up bra). The measurement should be made around the fullest part of her bustline and measured to the nearest half inch. When measuring, be sure the tape at the model's back is

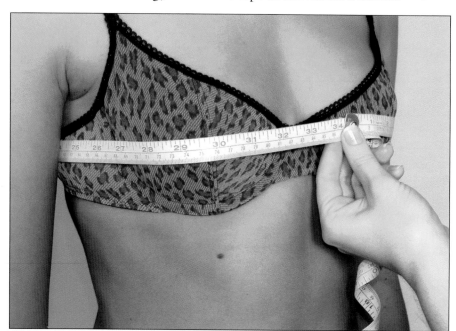

Measuring the bust.

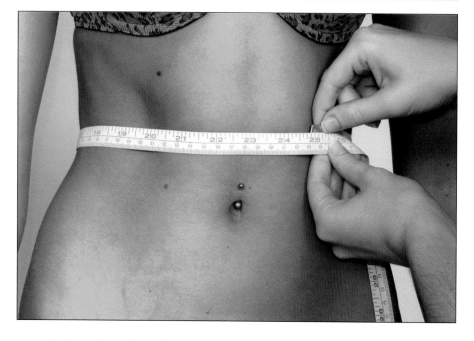

Measuring the waist.

kept level with the tape across her bust. The cup size, which women almost always know already from purchasing bras, should also be listed.

Waist—Measure the slimmest part of the model's waist. Measure to the nearest half inch.

Hips—Measure fullest part of the model's hips, including the buttocks. In the front, this is usually about where the top of a woman's bikini bottoms would fall. In the back, it's the largest part of the buttocks (imagine where a sack dress would contact the body in the rear—this is where to measure). Most agencies are very particular about this measurement. Measure to the nearest half inch, and do not pull the tape too tight.

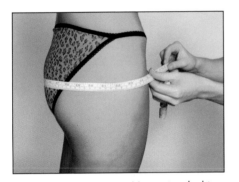

Measuring the hips.

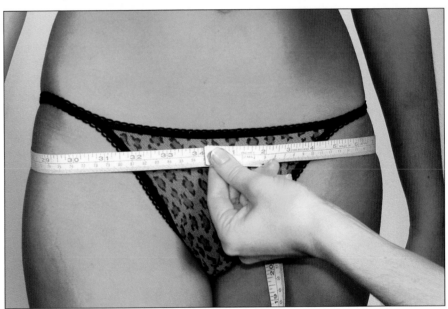

Shoe Size—Use the standard U.S. measurement for shoes. This is normally listed on the model's card and is listed to the nearest half size.

Thigh—Thigh measurement is not normally listed on a model's card. If it is requested by an agency, however, it should be measured at the largest part of the thigh. Be sure the model stands with her feet flat on the floor. Agencies use this measurement to determine a model's potential for weight loss. Measure to the nearest half inch.

Wrist—The wrist measurement is not normally listed on a model's card; when requested, however, it should be taken at

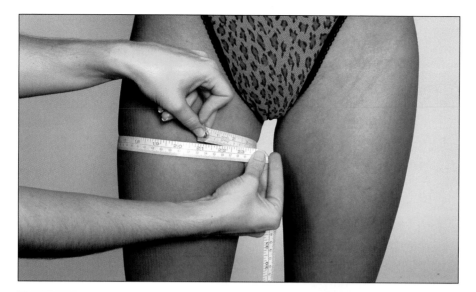

Measuring the thigh.

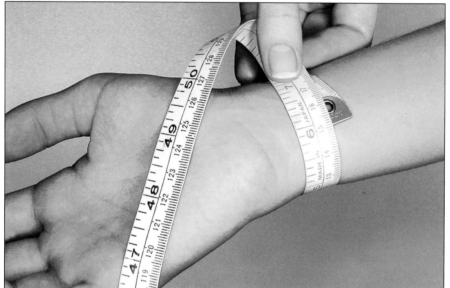

Measuring the wrist.

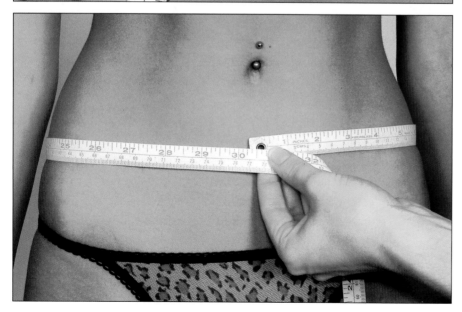

Measuring the drop waist

the smallest part of the wrist just below the wrist bone. Agencies use this measurement to determine a model's potential for weight loss. Measure to the nearest half inch.

Drop Waist—The drop waist is the measurement that is generally used for a waist measurement for jeans or pants. The measurement is taken two inches below the navel. Measure to the nearest half inch.

Inseam—This is the same measurement, from the crotch to the ankle, that the general public uses for an inseam measurement for jeans or pants. Measure to the nearest inch.

When working with male models, you'll need to provide the model's height, weight, chest measurement, inseam length, and shoe size. These are measured exactly as they are for female models, so just follow the instructions given above.

When you've completed your measurements, convert the figures into metric. Models will need them in this format when they are being considered for work in Canada, Japan, or Europe.

Final Profile Sheet. After the model has her hair and body in optimal condition, we reshoot the profile photos. Then, and along with the portfolio, we submit them to agencies. With this profile sheet in hand, the agencies have a visual reference as to the model's "actual" look and how well she photographs. This second set of shots also gives the model a visual reference of the progress she has made toward her goals.

When working with male models, you'll need to provide the model's height, weight, chest measurement, inseam length, and shoe size.

2. The Consultation

■ EVALUATING GOALS, MARKETS, AND EXPECTATIONS

The next step is the consultation. This is the time of major decisions for the model and/or her parents. I suggest that you use the following format for the meeting:

1. Discuss opportunities appropriate to the model's age. Some of the guidelines regarding age are as follows:

 a. No nudity for models under eighteen.
 b. European agencies usually do not offer contracts for models under sixteen.

LEFT AND FACING PAGE—During the consultation, you'll discuss with the model the kinds of work that are most suited to her. This will vary widely with her interests, age, and height.

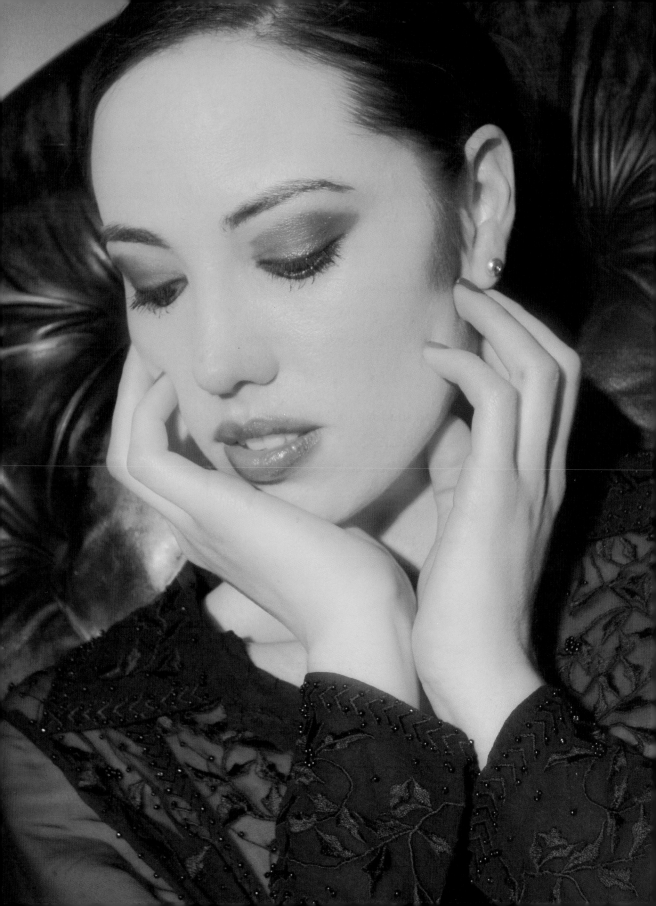

GOALS

Date: _____

Why do you want to be a model?

How much of a commitment are you willing to make?

Hours per week? _____ Per month? _____ Per year? _____

How much of a financial investment are you willing to make?

Monthly _____ Yearly _____

Do you have friends and family to support you? Do your parents support you?

Are you willing to give it a year before you become frustrated?

What do you hope to gain?

Financially:

Travel:

Personal Growth:

Remember, you can't achieve your goals in any career overnight. Success takes time, knowledge of the industry, and powerful marketing tools.

Success in modeling requires a significant personal and financial commitment as well as great determination.

c. Parents sometimes emancipate their minor children so that they may function as adults and can sign contracts for themselves, especially overseas.

d. No alcohol promotions or print work for any model under twenty-one.

e. No tobacco promotions or print work for model who is under eighteen.

f. Parents and models under eighteen need to discuss their family values concerning swimwear, thong swim-wear, and lingerie before the model goes on a specific audition.

g. When shooting their portfolio photographs, older models may want to target clients that use older models in advertisements to sell their products. For example, high-end jewelry clients rarely use young models to promote their products because they are not representative of their buyers.

2. Discuss the model's height and her potential markets. Refer to the chart on page 14 to help explain this to the model and her parents.

3. Discuss her weight and take detailed measurements. Be sure to advise the model to bring a leotard or swimsuit to the consultation so appropriate measurements can be taken. The needed measurements and how to take them are detailed on pages 18–23.

4. Assist the model in filling out the statistics sheet (see page 19), noting areas that need improvement.

5. Discuss the various categories and determine a target market.

After an evaluation with a professional stylist, encourage young models to become comfortable doing their own makeup with the professional's comments in mind.

6. Have the model complete the goal sheet (see page 26) and go over it with her.

7. Direct your makeup artist to evaluate the model's hair and skin, and identify her best features. Encourage young models to become comfortable doing their own makeup with the professional's comments in mind. This will be important as the model begins to go out to meet prospective employers and to attend auditions. She'll need to look her best for these events.

Photographers should also learn to do basic makeup to assist their inexperienced models, but more importantly to

facilitate communication with the established makeup artists on shoots. Basic makeup knowledge is extremely valuable when you are trying to explain your preconceived vision.

Good hair salons will offer basic makeup training for a nominal fee. Most modeling agencies also have a list of makeup artists they recommend. It is strongly advised that a makeup artist do a test shoot with the photographer to establish a good working repertoire before they are hired to perform makeup for a shoot involving a paying client.

8. Using the "Types of Work" section on pages 34–38, direct the model to select four to five types, based on her strong points, on which to focus in her portfolio. Discuss these

Photographers should also learn to do basic makeup to assist their inexperienced models, but more importantly to facilitate communication with the established makeup artists on shoots.

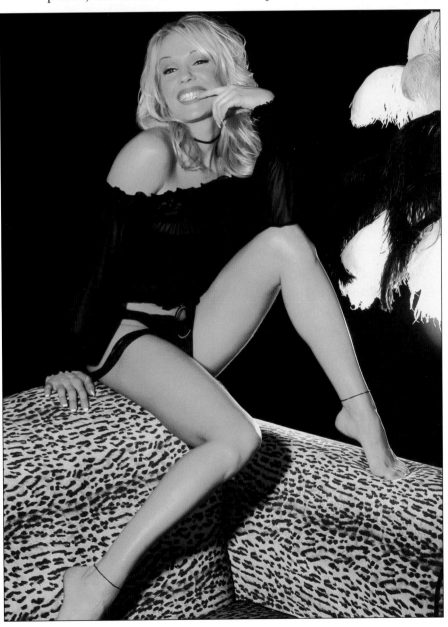

choices with her to ensure the selections are appropriate to her age, body type, and maturity.

9. Direct the model to your hairstylist or have her discuss your suggestions with her hairstylist. Give the model the profile shots showing her hair so that the stylist will understand the specific needs.

It it important that the stylist understands the need for the model's hair to be as versatile as possible and not too trendy. Some new models and many hairstylists get caught up in the trends that are shown in magazines. By fashion-industry standards, however, those trends are already outdated—in many cases, those "trendy" photos were actually shot a year in advance. Fashion photographers need to create new trends, not copy published ones. (Established models may sometimes be able to get away with trendy cuts or styles, especially if the cut was required by a client. Many top models also have an extensive collection of wigs and falls they can use to change their looks.)

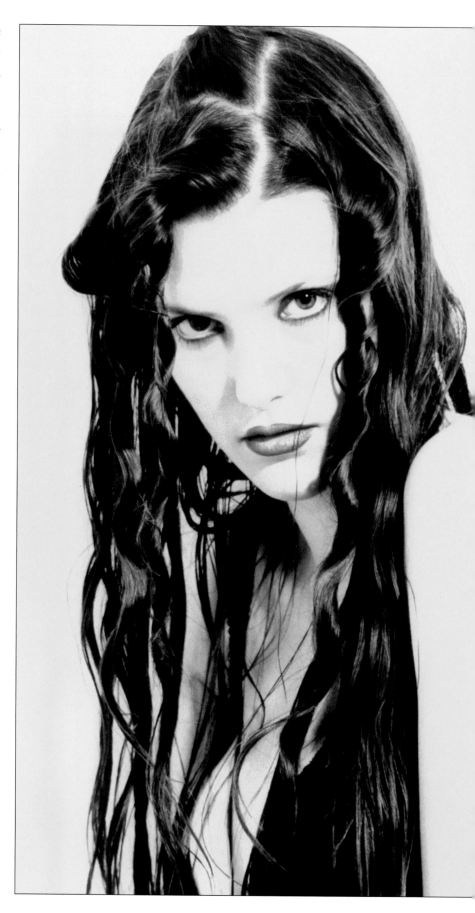

Long hair is the most versatile for a model, since shorter cuts tend to go out of style more quickly.

The model's hair color and style must be complementary to her skin coloring and, again, appeal to a wide range of potential clients.

10. Direct the model to develop a "mock" portfolio. Details on this process are included in the following section.

■ THE MOCK PORTFOLIO

The final step of the consultation is to ask the model to create a mock portfolio. Using photos from magazines, ask her to compile a collection of both head shots and body shots that she would like to see in her portfolio—shots where she could see herself replacing the model. This will serve two purposes:

1. It will show you, the photographer, where the model sees herself and help you to create a concrete visualization of her goals.

2. It will provide you a guide for the shooting of her portfolio.

The construction of the mock portfolio is not a one-step process. I have found that the first grouping is often based on wishful thinking and media hype. It takes a bit of gentle guidance to teach a young prospective model to look at herself realistically and develop a useful mock portfolio. However, this is absolutely necessary before proceeding with the development of her actual portfolio.

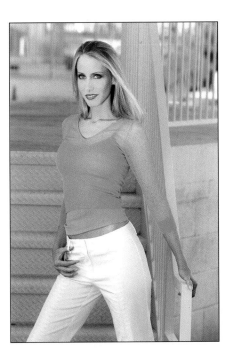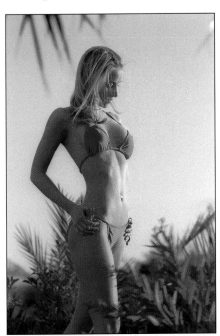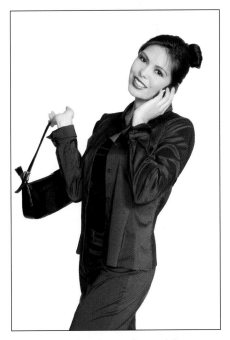

For the mock portfolio, have the model put together a collection of diverse images in which she can see herself replacing the model.

When our team (hairstylist, makeup artist, and photographer) goes over a model's completed mock portfolio, we narrow down the images in her mock book to a few looks. Then, we start planning her photo session and coordinating the clothing for each specific shot. The mock portfolio acts as a reference guide.

The photographer and his/her team, along with the model, must coordinate all of their efforts to promote her particular assets.

Once you have been photographing models for a while, you can also use this mock portfolio to illustrate to the model what look you are trying to achieve in each shot. A model's job is to sell a product, article of clothing, or a mood. In each photo session for her portfolio, the *model* is the product. Therefore, the photographer and his/her team, along with the model, must coordinate all of their efforts to promote her particular assets.

■ FINAL CONSULTATION

When the mock portfolio is adequate, arrange a final consultation. Several months will normally have passed between your first evaluation and this final consultation. At this final meeting, you can check the results of her preparation based on your previous meetings. Now is the time for you, the model, and her parents to evaluate everything from the brightness of her smile to the measurement of her now-toned hips. Finally, you are ready to start shooting the portfolio.

3. Preparing for the Shoot

■ U.S./EUROPEAN VS. ASIAN MODELING AGENCIES

U.S. and European Agencies. For the major agencies in the U.S. markets and most of Europe, your photos may be replaced. Every major agency has its own photographers, requirements, and style. Also, agencies often have their new models do shoots with established photographers in their area—both for the experience this gives the models and in order to introduce the new model to the photographers. The goal of the shots you will create for the model is to capture the attention of a major agency, and hopefully to obtain a contract for the model. As an added bonus, if your shots interest the agency, sometimes they will later use your services to test a prospective model found by their scouts as they tour the country.

A model's comp card is a promotional piece, featuring photos and contact information that she uses to attract potential clients.

Asian Agencies. For the Asian market, such as Japan and Taiwan, the portfolio will stand "as is." The photos must be sent to Asia, where the model's "cards" (see next page) will be printed and distributed to clients as part of a marketing effort that begins well before the model leaves the United States. Immediately upon arrival in Asia, the model must be ready to work. Time is of the essence, as a typical model's contract in Asia in normally limited to just two short months (although some models stay three months). Because of this timeline, a working portfolio is an absolutely necessity.

■ COMP CARDS

In addition to a portfolio, models will need to have comp cards to get started in the business. A model's comp card is a promotional piece, featuring photos and contact information that she uses to attract potential clients. Usually, the model's agent keeps a good supply on hand, and the

model has a few with her at all times. These cards are usually 6x9 inches in size, but can also be made the size of a postcard to be mailed as promotional pieces. The number of photographs that will be used varies, but there is usually one on the front and several (three or four) on the back. The cards are produced by independent printing companies and usually run several hundred dollars per thousand. Many photographers can provide layout services and recommend a good printer.

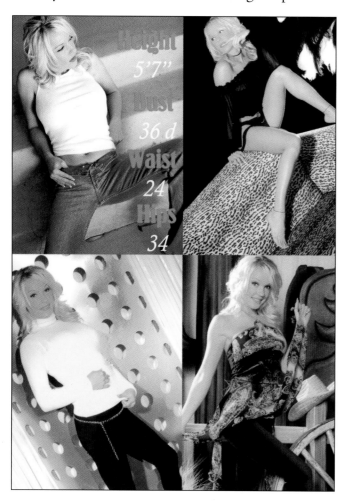

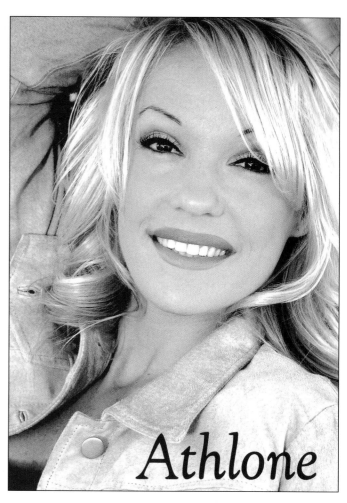

Athlone's model card features five contrasting photos along with her measurements.

■ QUALITY

The quality of photos in a model's promotional materials must be exceptional—even test shots must be carefully planned with a purpose in mind. Be fair to the models. Many agencies would rather see snapshots than poor-quality professional photos. Before every shoot, ask yourself what part of the model's "product" you are showing—physical beauty, legs, lips, sensuality, etc.

■ TYPES OF WORK

Decisions about the style and type of images a model needs for her portfolio should not be made arbitrarily. The target market you have decided on for the model will have its own tastes and needs—which you must

MODEL RELEASE

Name: _____

Address: _____

City: _____ **State:** _____ **Zip:** _____

Home Phone: _____

INFORMATION

Hair: _____

Eyes: _____

Sex: _____

Height: _____

Weight: _____

Date of Birth: _____

Bust/Cup: _____

Waist: _____

Hips: _____

I, _____, authorize the use and reproduction by
_____, or anyone authorized by him, of any and all photo-
graphs that have been taken of me (including negatives, positives, and digital captures) without
future compensation to me. All negatives, positives, and digital captures, together with the
prints, shall constitute his property, solely and completely.

Date: _____

Model: _____

Parent (if model is younger than 18 years): _____

Photographer: _____

SPECIAL SKILLS

Name: _____

Date: _____

Please rate yourself on a scale of 0–10, with 0 being the least proficient (not at all) and 10 being the most proficient (excellent). Be honest. Feel free to editorialize and comment. If you acquire new skills (sailing, pogo stick, another language) or give up an old one (you resolve never to play harmonica again or quit cross-country skiing) be sure to update your rating. If you don't know what something is, you probably don't do it.

Baseball	Swimming	Horseback riding	Hockey	Comedy
Softball	*underwater*	*Western*	Fencing	Improvisation
Football	*diving*	*English*	Surfing	Music
Handball	*high diving*	*bareback*	Wind Surfing	*piano*
Soccer	*tricks*	*jumping*	Boogie Board	*violin*
Basketball	Scuba Diving	*roping*	Body Surfing	*flute*
spin a basketball	*certified*	*dressage*	Parasailing	*clarinet*
Volleyball	Water Skiing	Gymnastics	Good with Animals	*harp*
Racquetball	Sailing	*cartwheel*	Archery	*organ*
Rugby	White Water Rafting	*handstand*	Stilts	*trumpet*
Cricket	Canoe	*balance beam*	Mountain Climbing	*trombone*
Jai Lai	Rowing	*rings*	Rappelling	*saxophone*
Bocce Ball	Darts	*parallel bars*	Rock Climbing	*guitar (electric)*
Tennis	Pool	*uneven parallel*	Hiking	*guitar (acoustic)*
Ping Pong	Billiards	*bars*	Backpacking	*tuba*
Badminton	Pogo Stick	*tumbling*	Dance	*banjo*
Lariat/Lasso	Frisbee	Skiing	*ballet*	*other*
Hang Glide	Hula Hoop	*downhill*	*jazz*	Languages
Sky Diving	Yo-Yo	*jumping*	*tap*	*French*
Fire Baton	Jump Rope	*slalom*	*modern*	*German*
Cheerleading	*double Dutch*	*cross country*	*square*	*Italian*
Unicycle	Bowling	*snowboarding*	*clog*	*Japanese*
Bicycling	Jogging	Track and Field	*disco*	*Chinese*
mountain	Aerobics	*sprint*	*ballroom*	*Spanish*
racing	Weightlifting	*broad jump*	*belly*	*Vietnamese*
BMX	Free Weights	*javelin*	*break*	*Polish*
tricks	Boxing	*high jump*	*hula*	*Portuguese*
Motorcycle	Kick Boxing	*hurdles*	*hip-hop*	*Swahili*
Motor Scooter	Golf	*pole vault*	Clowning	*Dutch*
Dirt Bike	Fishing	*shot put*	Magic	*Russian*
Skateboarding	*deep sea*	Roller Skating	Mime	*other*
tricks	*fly cast*	Ice Skating	Juggling	Other Special Skills

keep in mind as you shoot and create the model's portfolio. The categories below will give you some guidelines.

Editorial Print. Modeling for magazine articles and features (not advertisements). This same style of image has also become quite popular in many advertisements, but is usually seen there in conjunction with some type of text to identify or describe the featured products (logos, product captions, etc.).

Catalog/Commercial. Modeling for retail catalogs produced by manufacturers or distributors to sell their products or services.

Models are also used in advertising images to promote events—here, a music festival in Las Vegas.

Advertising. Use of models to wear or demonstrate a product or service in magazines, newspapers, brochures, point-of-purchase displays, or packaging.

Junior. Use of models who are 5'6"–5'7" and 13–19 years of age for editorial print, catalog/commercial, or advertising functions, usually for products or services targeted at a younger audience.

Plus Size. Use of models who are size 14–18 and 18–28 years of age for editorial print, catalog/commercial, or advertising functions, usually for products or services targeted at a plus-size audience.

Specialty. Use of models who specialize in one aspect—hands, feet, legs, facial features, etc.—for editorial print, catalog/commercial, or advertising functions where these qualities are to be emphasized.

Nude or Figure. A type of work best suited to models who are 18–24 years of age with good to excellent skin and, normally, with a fuller bustline.

Runway. Modeling for fashion shows to exhibit a designer's or manufacturer's garments. Models must be quite tall (usually 5'8"–6') to be suited to this field.

■ WHAT CLIENTS ARE LOOKING FOR

The physical characteristics that a particular client will be looking for in a model will vary greatly depending on the product being sold, the market for that product, the style of the advertising campaign, and much more. The following is a sampling of what clients typically look for.

Models with one especially good feature may be good candidates for work selling a related product.

Swimwear and Lingerie. The model should wear a 34B or larger brasserie and have naturally darker skin (or a light tan). For this type of work, clients prefer well-toned models with natural curves—neither boney nor muscular body types. The model should have little body hair and good skin, free of moles or scars.

Hand Models. Hand models generally wear size 6½–7½ gloves and size 4½ to 5½ rings.

Hair. In most cases, clients prefer models with hair that is of a versatile length. A uniform coloration is desired, and lighter colors are preferred, as dark colors are harder to photograph. Of course, a model's hair should also be healthy and well maintained.

Product Models. Models with one especially good feature may be good candidates for work selling a related product. If a model has good feet and legs, she may be suited to model panty hose, socks, grooming products, shoes, jeans, etc. A model with good teeth, good skin, and small pores may be suited to work for beauty companies, modeling make-up and other beauty products. To succeed in this type of work, the model should also have a long, slender neck, full lips, and a small, narrow nose.

4. Makeup

The single most dramatic change a photographer can make is a dramatic change in the hair and makeup style. To facilitate this change, models must also provide a well-maintained "canvas"—which requires developing good skin and nail care habits.

■ SKIN AND NAIL CARE

Skin. The upkeep of a model's skin is crucial to her modeling career. A basic cleansing routine must be established and used twice a day, every day. If acne or serious skin problems are present, a physician or dermatologist needs to be consulted regarding treatment.

Makeup and hairstyling are among the most dramatic changes a photographer can make in a model's appearance.

1. Begin with a gentle makeup remover, if needed.
2. Using a gentle cream or liquid cleanser, use the fingertips or a soft wash cloth to wash the face.
3. Use cotton balls soaked with toner to close the pores on the face.
4. Apply a small amount of moisturizer to the face with the fingers in a patting motion. Dry skin needs more moisture, oily skin needs none to very little moisture, and some skin types require selective application of moisture.

These simple procedure will ensure that clear, healthy skin is what shows through in a model's photographs. Basic maintenance also requires a good diet and drinking plenty of water.

Nails. Along with good skin, a model's hands and nails must also be in top shape. When a photograph shows the model's hands, unhealthy, chipped nails and dry, scaly hands will be highly visible and can ruin the image.

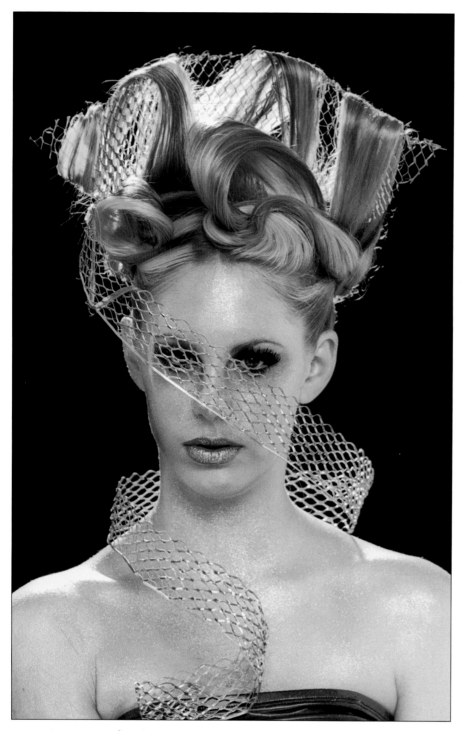

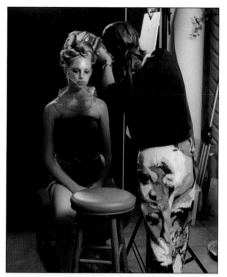

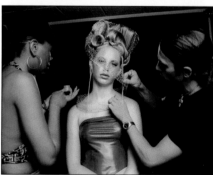

A model's hair and makeup requires professional work when the effects are this wild. Above, stylists perfect the model's look. The final image, left, was used on a magazine cover.

A basic manicure and a good hand moisturizer can work wonders. In a manicure, the nails are clipped to the desired length, then filed and shaped. The cuticles should be gently pushed back and any hangnails clipped. The cuticles should never be cut; they are vital to keeping the nails healthy.

Apply a colored polish that accents the photo shoot. Clear polishes that contain hardener can also be worn to help the nails grow stronger. Acrylic nails may be worn if the model's own nails are not long enough.

■ BASIC MAKEUP

Concealer/Highlighter. This product covers under-eye circles, as well as blemishes, scars, flaws, skin discoloration, and other imperfections. A light-colored concealer works best for most skin tones. Apply before the foundation.

Foundation. Many types of foundation are available, including liquid, cream, pressed, pan stick, and pancake. You should apply the foundation with your fingertips or with sponges, using a color that matches the model's skin tone exactly or is possibly a little lighter. Be sure to cover the eyelids. Blend the foundation down the neck to avoid a line of demarcation between the jawline and the neck. (Try not to get the makeup too low, however, or it will stain the collar of the model's garment.)

Translucent Powder. Applying translucent powder after the foundation (and before the eye shadow, blush, or any other contouring cosmetics) sets up the makeup and makes it stay on much longer. It also creates a matte finish on the face, eliminating any shiny areas. You should apply translucent powder with a soft powder brush to blend and smooth the powder.

Eyeliners. Although liquid eyeliners are available, pencils are more common today and are easier to work with. Use sparingly to enhance the eyes, unless a specific dramatic look is needed.

Eye Shadow. For the best results, eye shadow should be used to subtly enhance the eyes, not add obvious color, so use as little as possible and stick to neutral or subdued colors. Stay away from frosted shadows and other trendy

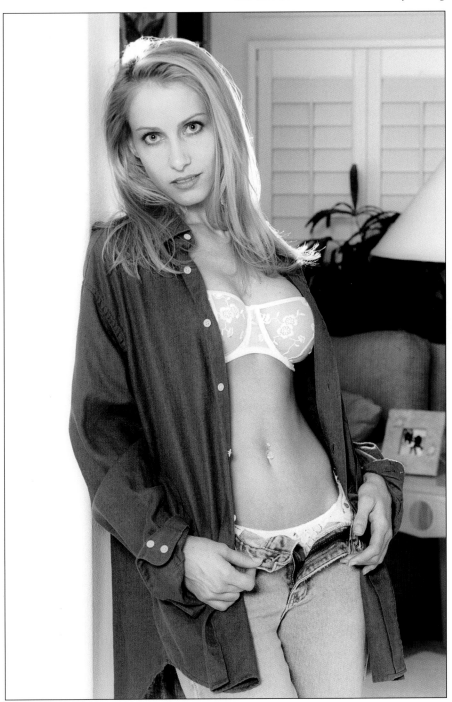

Translucent powder creates a matte finish on the face, which eliminates any shiny areas.

looks. The most important tip for applying eyeshadow is to make sure that it is blended well.

Mascara. Use two or three light coats of black or brown mascara for the most natural look. Other colors can be used for special effects. Mascara needs to be replaced every two or three months, as bacteria growth is very high and can cause eye infections.

Lip Liner and Lipsticks. Outline the edge of the lips with liner, using the same shade as the lipstick. Lip liner is used to keep the lipstick from bleeding out past the lip line but can also be employed to increase the apparent size of the lips or enhance their shape. When using lip liner in this way, you should be careful to draw the desired outline of the lips only very slightly outside the lip line. Straying too far from the natural line of the lips will create an unnatural look.

When you've finished with the lip liner, fill in with lipstick using a downward motion with a lip brush. This will fill in the tiny cracks and creases that give lips their texture.

To finish, set the lips with powder. You can also use lip gloss to give the lips a glossy appearance when needed.

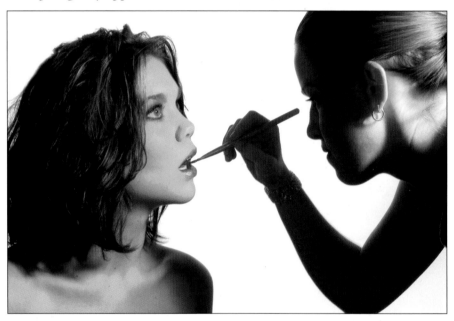

After applying lip liner, lipstick is applied using a downward motion with a lip brush.

Blush. You can apply blush lightly to the cheekbone to add color. Use blush very sparingly or not at all—especially when shooting black & white, where the blush will register as a shadow and make the cheekbones seem to recede.

Contour. Two shades darker than blush, contour can be applied under the cheekbone to emphasize the shadow and enhance the structure of the face. Contour can also be used to shape other facial features by creating areas that appear to be in shadow.

5. On the Shoot

Over the years I have heard many people refer to the photographer's or artist's "eye." This refers to an individual's ability to previsualize a photograph or a piece of art before starting the production process. This previsualization is necessary any time you work with models.

To have a successful shoot, you must establish an idea or concept and be able to communicate it to the model before you start working. This will establish credibility with the model (or the client) and will allow the whole team to work in a unified direction. One way to do this is to show sketches or sample photographs of the style, the poses, and the overall feel of the photograph you want to create. The sketches or photographs can be samples of other photographers' work that you admire. Make a resource collection of these samples to help hone your own likes and dislikes. You don't need to copy every detail of another photographer's images to make your photographs successful, just emulate the elements of the style, lighting, or poses that mesh with your personal vision.

To have a successful shoot, you must establish an idea or concept and be able to communicate it to the model before you start working.

When creating an image, especially when working with models and trying to emulate another photographer's work, be sure to look for ways to add "heart." Let your personal feelings—likes and dislikes, loves and passions—show in the work. A model is not an inanimate object that can sit there all day. Her job is to communicate feelings and add emotion to the photograph. By planning out your ideas and communicating them to the model (and your whole team) before the shoot starts, you'll be best equipped to capture the model's ability.

Imagination is the most powerful tool a photographer can possess. Technical proficiency can be learned through education, experimentation, and practice, but imagination comes from within. Studying the

work of current and past artists and photographers will assist in your imaginative process and help establish your style by defining your likes and dislikes. The following are suggestions for some of the criteria you should consider when designing your images.

■ THE MODEL'S COMFORT

An important thing to keep in mind when photographing models (especially inexperienced ones) is to make the shoot comfortable for them—after all, being in front of the camera can be intimidating for anyone. I love making models feel the confidence they need to be at their best on camera. I do this by focusing on their strengths and getting them pumped up about the shoot.

LEFT AND FACING PAGE—Being in front of the camera can be intimidating for anyone. As a photographer, a big part of your job is helping the model feel comfortable enough to do her best work.

I also use stories to make it clear to them that being in front of a camera in the studio isn't like being in front of Mom's camera at a picnic. One of my favorite stories is about a *Sports Illustrated* swimsuit photographer who shot 40,000 pictures on location to get sixty for print—and that was with a full makeup and hair crew, photographic assistants, and professional models! The lesson is that not every photo has to be perfect.

In a portfolio or on a glamour shoot, it also helps to remind your models that no one will see the photo before them, so if they hate an image, they can choose not to use it. Of course, this is not true for professional shoots, where models normally won't see the photos until they are published.

Constant reinforcement of a positive nature is very important throughout the whole shooting process. Many models wait to hear positive feedback before they proceed to the next pose.

■ BACKGROUND SELECTION

Look for unique locations that will make your model's photographs stand out from the rest. For example, if the model is looking for work in Asia or Europe, try to include some photos that couldn't be made there because they include features that are unique to your area. This could mean including characteristic architecture or landscapes, or anything else you can dream up.

Backgrounds can be as simple as white seamless paper or as complex as a crowded city street. They can be classic or contemporary, subtle or bold. But whatever type of background you choose, be sure to use poses and clothing

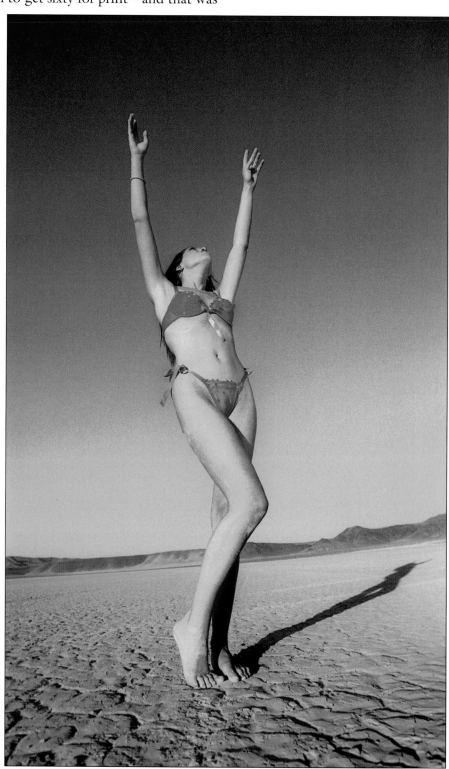

Including unique backgrounds can make the model's images stand out—but the background should never compete with her for attention.

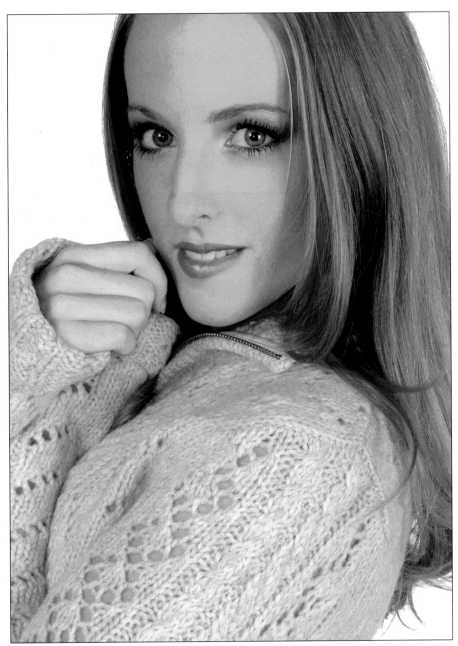

Textured sweaters work well with head-shots because they create a nice contrast in texture between the rough sweater and the model's smooth skin. Notice how the tilt of the body and the placement of the hand bring your eyes right to the model's face in this image.

that either match its character (a woman in a stylish suit on a busy city street) or contrast with it wildly (a woman in a formal ball gown in the desert).

Most of all, the background should flatter the model and be used in such a way that is doesn't compete with her for attention. If a background seems distracting, try throwing it out of focus by posing the model farther away from it.

■ CLOTHING

When shooting images for a model's portfolio, I have her bring a lot of clothes to the studio (better too many than too few!). The clothes you finally decide on should be ones that are not too trendy. Clothes like these will look dated quickly and require more photographs be taken. Once a model is well established, she can add more trendy items to her portfolio. For the amateur model, try to accomplish a few basic shots: a basic head shot, a glamour head shot, a basic full-body shot, etc. Try to show the model's simple beauty with a clean and fresh look instead of a highly stylized one.

When the clothes are an important part of the image, make sure that they fit right (or at least appear to fit right). Fit problems occur frequently and have to be worked around. You can use clips behind the model to pull clothes tighter if they are too big, or you can pose the model in some way that disguises the poor fit—but you have to do *something*. Otherwise, neither the clothes nor the model will look as good as they could.

Clothes can also be the source of inspiration for an image, so don't think of them only in terms of an accessory. When a unique or appealing or very flattering garment catches your eye, think of ways you could build an image around it. Think of backgrounds and poses that could be used to highlight what it is about the clothing that particularly appeals to you.

■ LIGHTING

Lighting is one of the most versatile tools in the photographer's arsenal. The majority of new fashion looks are created in the controlled environment of the studio, the place where the photographer has the ultimate control over every aspect of the photograph. When you are working in the studio, strive to use your lighting in ways that most flatter the subject, emphasizing her best characteristics and minimizing any problems.

If you are still working toward mastering studio lighting, try scheduling your shoots during the "golden hours"—the hour just after dawn and the hour just before dusk. During these hours, the light is warm in color and gives the skin tone a beautiful glow. Also the light is low on the horizon, so it will not cause the shadows on the model's eyes that are seen with unmodified sunlight at other times of the day. This means that you can work without the need for fill flash or reflectors, giving you more time to focus on your posing and background selection skills.

If you are still working toward mastering studio lighting, try scheduling your shoots during the "golden hours."

Because lighting is a book in itself, I encourage you to read through the technical data for the images in chapters 6, 7, and 8. Here you'll find detailed information on how the various images were lit, including diagrams for your reference. There are also countless books on photographic lighting on the market that can be of great use as you expand your skills. Several of these are listed in the last pages of this book, but you can find more at your local library or online.

■ POSING

When photographing people, the photographer must exert more energy than the model to bring life into the photograph. Ask yourself a few questions before shooting:

- What are we trying to show/sell?
- How do the elements of the pose relate to the background, the clothing, or the product?
- What pose is appropriate for the clothing, product, or the desired feeling of the photograph?

Three particular body parts require special consideration when working in fashion/model photography. These are the eyes, the feet/legs, and the hands. They are direct contributors to the overall design and feeling of the photo and play a vital role in showing off the product, whether it is a fashion garment, a commercial product, or the model herself.

The Eyes. Eyes can give a photograph a sense of power, depth, and intimacy. If used incorrectly, the eyes can also ruin an otherwise great photo.

FACING PAGE—When photographing a model, you need to ask yourself what it is about her that you want to emphasize.

In commercial shots, the model generally will look off-camera, since the product takes first billing. For portfolio development, however, the opposite is true. The model is the product and, therefore, the eyes should be looking at the camera, and the photographer should always focus on the model's eyes. This is what draws the viewer and forms a connection between the model and

FACIAL EXPRESSIONS

Charming	Shy	Flushed	Calm
Laughing	Curious	Playful	Cheerful
Sleeping	Confident	Angry	Alluring
Serene	Happy	Coy	
Sensual	Excited	Devilish	
Amused	Surprised	Sarcastic	

the possible client. This connection is vital and can make the difference between success and failure. To establish a connection, I remind the model to focus on the lens and "flirt" with the camera. I ask the model to imagine she is placing her face on the film, and look through the lens to the film.

Inexperienced models often stare at the camera in a "deer in the headlights" manner. To avoid this, I suggest the model periodically look away, and then return focus to the camera so as to maintain a fresh, spontaneous look. If the head is at an angle I don't want to lose, I'll instruct the model to simply lower his or her eyes, then slowly raise them to the camera. These models also tend to look to the photographer or stylist rather than connecting with the camera lens. It is necessary to remind them that they need to connect with the person viewing the photograph down the road, not those in attendance at the shoot.

Another technique that works well is humor. I gently tease the models about silly topics—just to break the tension and keep the shoot flowing in a light-hearted manner. Some of the most spontaneous expressions I've captured have been the result of some silly, teasing comment. Be careful, though; this only works if the photographer has developed a comfortable, communicative relationship with the model.

The Feet and Legs. The feet are rarely shown alone in a photograph except when shooting a particular product, such as shoes. However, selecting a good pose for the legs and feet is vital when creating a full-length shot or a shot where the model is one element in a wide image. The feet and legs contribute so much to the overall feeling of the photograph—from the tilt of the hips, to the position of the feet, to the casualness of the stance, or the relaxed angle of a seated model.

A good way to learn how to pose the feet and legs is to tear out photographs from magazines that you like. Then draw lines on these tear sheets indicating where the bones are positioned in the model's legs. (This is a good exercise for posing the rest of the body, too.) Then, step back and evaluate the feel of the photograph. Does the position enhance this feel?

FACING PAGE—Selecting a good pose for the feet and legs is imperative in full-length images. Here, note that the model's heels are raised, a posing technique that makes the legs look their most slim and toned.

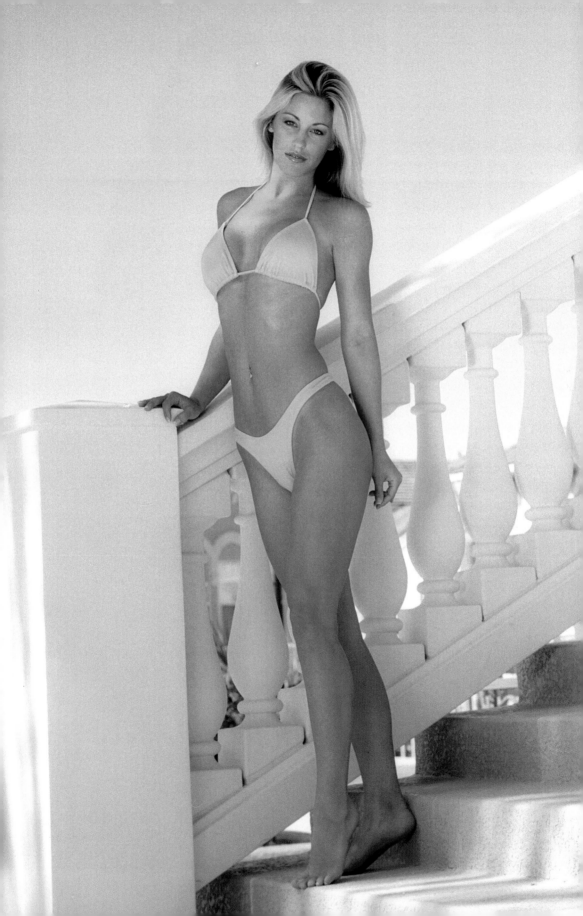

I always ask the model to show me a heel. This ensures that the viewer sees the front of one leg and the profile of the other.

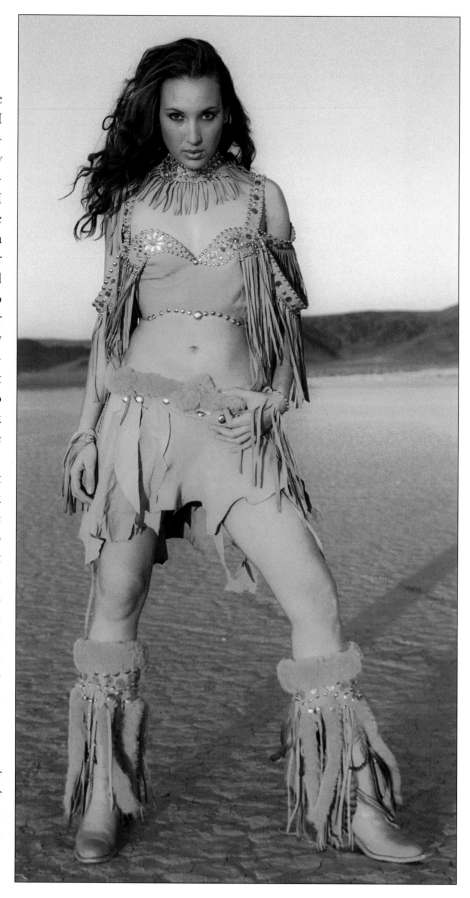

Notice how legs and feet are rarely shown straight on. When I am shooting a model I am constantly asking the model to show me a heel. Even when I am cropping the feet out of the photo I have the model make sure that one heel is always visible to the camera angle. This ensures that the viewer is seeing the front of one leg and the profile of the other. It also forces the model to position her hips at an angle to the camera. Try to avoid shooting the model standing flat footed. Shooting the feet with the heel raised adds height to the model, makes the legs look more toned, and creates a more graceful attitude.

The Hands. How important are the hands? Very. If you think otherwise, keep your eyes open the next time you're talking to a group of people and you'll quickly see that hands are used extensively to add emotion and interest to the words that are being spoken. That makes them an important part of the process of communication. Because of the importance of hands in our daily lives, a viewer's eyes will always look at the hands in a photograph to see what the hands are communicating.

When teaching a group of beginning models, I have one of the models cover her face and body so that all the group can see is her hands. Then I ask the model to demonstrate anger, love, impa-

tience, fear, reverence and various other emotions using only her hands. The models quickly get a visual understanding of how the hands can communicate so much of the feeling of a photograph.

When selling products (or when demonstrating the model's ability to sell products in images for her portfolio), the hands must work to illustrate the message of the photograph. A basic rule for hands is to make sure they are never both at the same level in the photograph. You should also be careful to keep the model's hands away from any problem area of her body. Placing hands there only draws attention to the area!

Here are a few of the general guidelines I like to use when posing a model's hands:

1. The hands should draw the viewer's eyes to the commercial product or to a particular feature on a garment (such as a pocket, zipper, lining, button, or the overall cut of the garment).

2. You should show the profile of the hand. The palm or back of the hand is really quite large and will demand too much attention—often drawing attention away from the model's face or the product she is selling. Also, age tends to be more visible on the backs of the hands. When you are working in a warm environment, the veins in this area often protrude in an unappealing fashion. There are some exceptions, of course. For example, if you were trying to show the emotion

Notice how each image communicates a different message. The first image shows the model's beautiful smile. The second portrays the product in a romantic manner. This was the image that the client chose, but it could also be used by the model. When comparing the first and third images, notice that the model's hair was cleaned up in Photoshop in the first image in order to help keep the attention on her eyes. In image three, the model's hair was not changed because her eyes were directed to lead the viewer's gaze out past the cup of coffee.

of fear, you might want to have the hands wide open and toward the camera in a "Get back!" position.

3. Keep the fingers together and in a slightly bent position. Spread fingers create too many lines for the viewer's eyes to read.

4. Keep the wrists straight or at a gentle bend upward toward the shoulder.

5. Keep the hands at the same distance from the camera as the body. Extending them out closer to the camera will make them look too large in proportion to the body.

6. When placing the hands in the pockets of a garment, keep part of the hand out of a pocket. Either hook the thumb into the pocket and leave the fingers out or vice-versa.

Getting the Right Pose. It is important to be very descriptive with posing. Being in front of the camera can make people nervous, but being clear with your instructions and making the session professional can really help. One trick to try is to have another person stand in for the model and allow the model to look through the camera so she can see what you are seeing and understand the posing. Finally, you may even try having the model pose without the camera in place, if that helps to relieve anxiety about the shoot. Once the shoot is under way, don't have the model change poses dramatically for every shot. Rather, ask her to change one small element per shot—the tilt of her head, the position of her hand, the angle of her hips, etc.

Have another person stand in for the model and allow the model to look through the camera so she can see what you are seeing.

■ WORKING ON LOCATION

When shooting on location, pay attention to non-photographic necessities such as sunscreen, insect repellent, water, a snack, towels, and an extra jacket. Professional models will normally assist you with this, because they maintain (and have with them at all shoots) a professional model's bag (for more on this, see page 108).

■ MEN VS. WOMEN

I photograph male models frequently, and there are several guidelines I follow. When compared with those used by female models, male models' portfolios do not need to show as wide a range of looks or emotions. Men should be photographed looking very casual. A little powder will suffice

for makeup. The photos should show the shape of the model's jaw; if he is shirtless, side lighting is also desirable to create harder lines and show off the chest physique. The idea is to convey a message of power, almost treating the model like a solid, strong piece of sculpture.

■ MARKETING A MODEL

In the next three chapters, you will see how a knowledge of the markets for models and careful examination of the prospective model's appearance, skills, and interests will help you design an individualized portfolio to meet her needs.

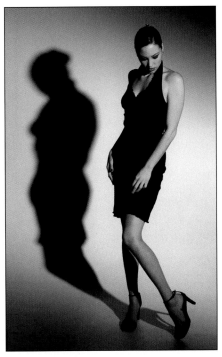

Being in front of the camera can make anyone a little nervous. Using clear instructions and positive feedback, though, will help put the model more at ease.

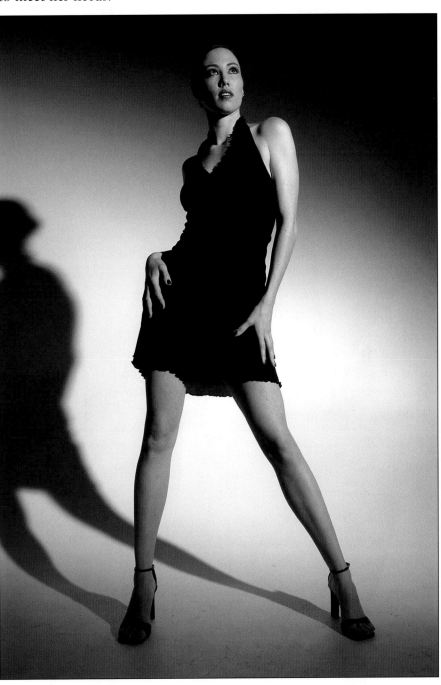

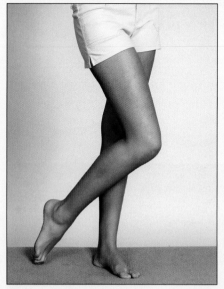
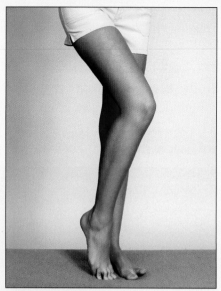
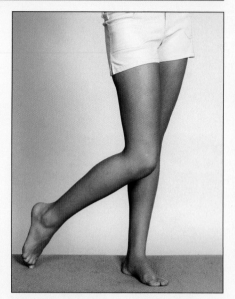
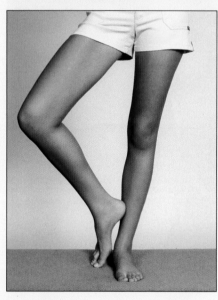
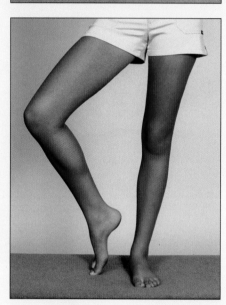
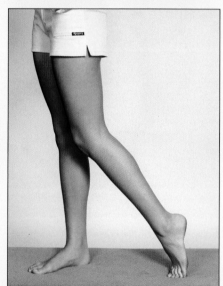
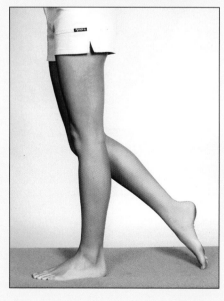
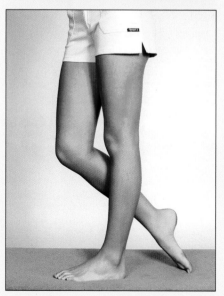
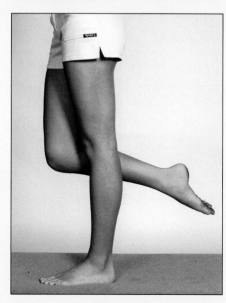

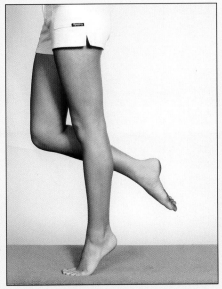

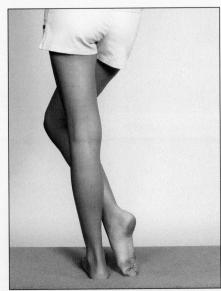

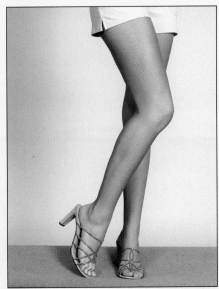

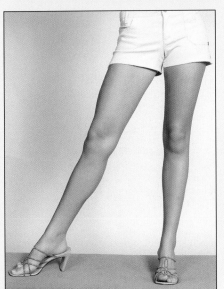

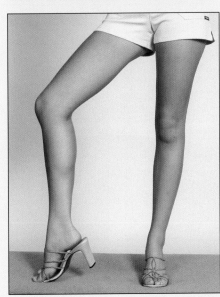

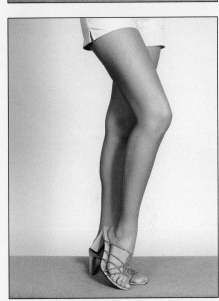

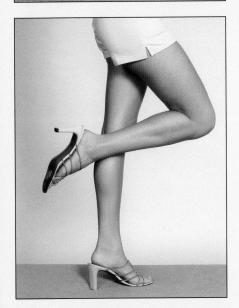

Don't let the model just stand with both feet flat on the floor. This is a static pose—and it definitely doesn't make the legs look their best. The poses on these two pages show a variety of looks, but you should also look for your own creative ways to pose your models in a flattering way.

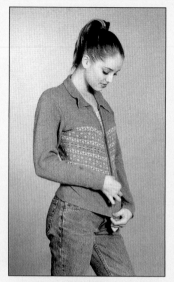

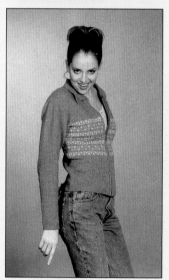

When you're working with a model, ask her to work on making small changes in her poses and expression. These little variations are easier for her and will help you both refine the look of the images you are creating so you'll get just what you want. In the images here and on the facing page, you can see that even these small changes can make a big difference in the image!

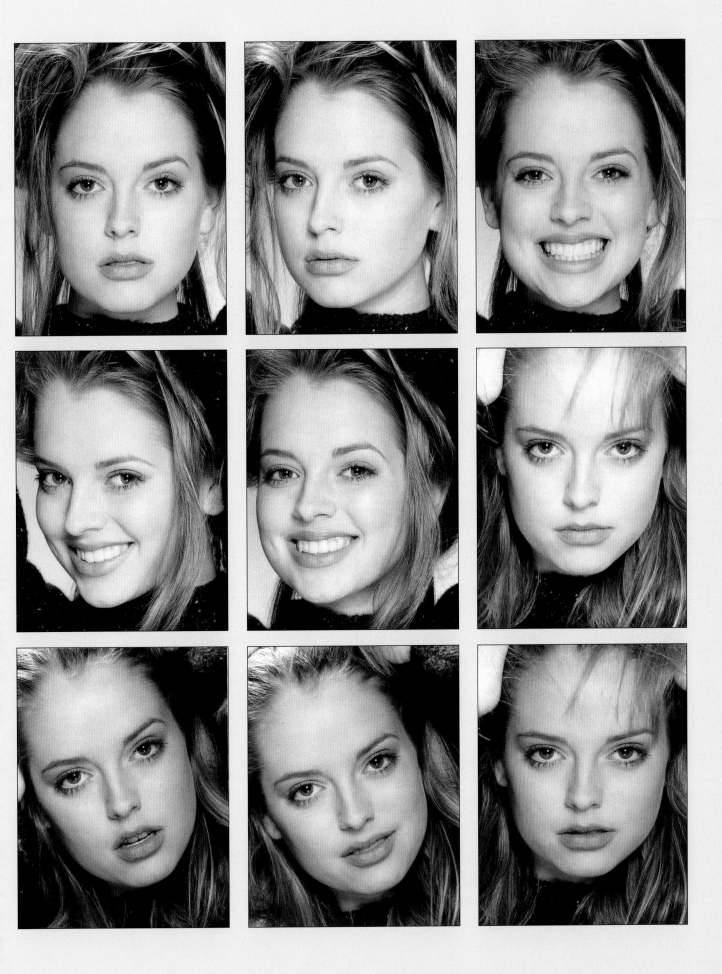

6. Andra's Portfolio

■ ABOUT ANDRA

I met Andra while helping to produce a model search/fashion show for a major New York agency at a mall in Seattle, WA. Andra had been working locally as a model on a part-time basis, and approached me about turning her hobby into a career. She was very driven, and I was impressed with a statement she made about her willingness to work hard to achieve her goals—the work involved in a successful modeling career is something many young women underestimate. Because Andra had also had many years of dance training, I knew she was especially aware of the importance of fitness, something that is also extremely important in the modeling business.

Andra had been working locally as a model on a part-time basis, and approached me about turning her hobby into a career.

We met to discuss her goals, and the limitations that some people in this business would place on her because of her height. At 5'6", her best immediate option was the Asian market. Thus we structured her portfolio in that direction. Because she has a sensual quality that is not desired in the Asian market (where a more wholesome, all-American-girl look is preferred), we shot additional photos to capture this aspect of her look. She can pull these from the portfolio she submits, depending on the client she is approaching.

Andra has become a very good model—she has a great attitude, professionalism, and work ethic. She also has what is referred to in the acting and fashion business as the intangible "it" factor. She provides input during photo sessions and has a "can do" attitude.

■ CREATING ANDRA'S PORTFOLIO

A model's portfolio should typically have between twelve and twenty photographs—enough to show versatility, but not so many that a poten-

tial client will lose interest. A portfolio should be structured so that it shows all of the model's strongest attributes (her legs, hands, swimwear figure, beauty, etc.). It is better to have a few photographs that really show off the model than to dilute the overall quality of the portfolio with weak pictures. If you include only the model's strongest images, you'll leave viewers with the impression that every time this model shoots, she has great photos.

Opening and Closing Shots. Your model's best shot—or the one you want the viewer to remember—should be placed as the opening photo in the portfolio. If one photo doesn't seem to dominate, then use the model's best head shot. At the closing of the portfolio, use the second strongest photo, or one that is similar to the shot you selected for the opening.

The only time it is appropriate to separate similar images is if you are using one for the front page and one for the closing page.

Arranging the Interior Images. The best way to arrange the interior images of the portfolio is to take all of the photographs out of the book and lay them on the floor. Then, begin grouping them and arranging them into patterns that seem to flow naturally from one photo to the next.

Grouping. When you group similar images together, the viewer's eyes will scan for the differences—for example, a different facial expression. Keep in mind that images don't have to be from the same shoot to work well together. The photographs could have other qualities that link them—such as a similar theme, background, or color.

Stuffing. If you separate photos from the same shoot, it will look like the model is "stuffing" her book. The viewer will feel disturbed, thinking he has seen this image before. The only time it is appropriate to separate similar images is if you are using one for the front page and one for the closing page. In this case, the separation lets viewers know that they have reached the end of the model's portfolio. It also reminds them of the opening image and encourages them to review the images they have just seen.

Blank Pages. If you place two unrelated images next to each other, they may compete and cause the viewer to lose sight of each individual image and just notice an unbalanced feeling. If you don't have two images that seem to flow well together, then leave one page blank. The blank page will force the viewer to really look at the single image.

■ CLOTHING SELECTION

When helping a model develop her portfolio, I ask her to bring to the studio all the outfits she has that she thinks could be used to help us create a wide variety of images. I then shoot snapshots of the outfits to be used as reference when finding backgrounds or determining the style of the image. When looking at the outfits, I try to determine what makes each

one special and how each outfit shows off the model. (Remember, the *model* is what we are promoting in her portfolio, not the clothes.)

For image 15 in the following sequence, I chose to make the predominant sleeves the main focus by using a pose that incorporated the model's arms with the background. This shows that the model can work well in her environment and accents a particular highlight of the clothing.

In image 5, I thought that the pattern and style of the clothing was interesting. With this in mind, I noticed that the late afternoon sun caused this nearby field to display similar color patterns. I would not have remembered the detail and the coloration of this garment if I had not shot snapshots of the outfits ahead of time.

I would not have remembered the detail and the coloration of this garment if I had not shot snapshots of the outfits ahead of time.

■ ANDRA'S PORTFOLIO

In order to preserve their grouping, the following six pages contain Andra's portfolio. Beginning on page 68, you'll find discussions of these images. These discussions tell you how the photos were made, and why each photo was included. Using this information, you'll begin to see the thinking that goes into every step of marketing a model to her desired customers. Unless otherwise noted, all of Andra's photos were shot on Kodak Elite ISO 100 slide film rated at ISO 80. A Nikon FE-2 camera was used with Nikkor lenses. Unless otherwise noted, all images were shot from a Bogen tripod and metered with a Minolta Flashmeter 3 or Gossen Luna Pro.

Image 1 (front)

Image 2

Image 3

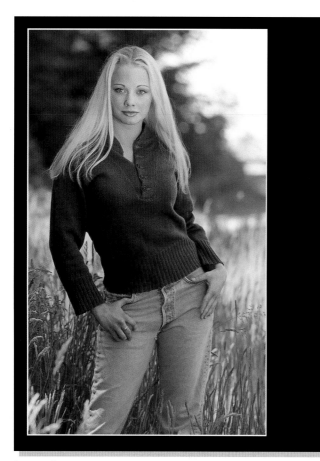

Image 4

Image 5

Image 6

Image 7

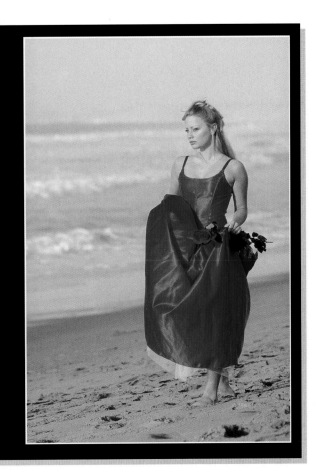

Image 8

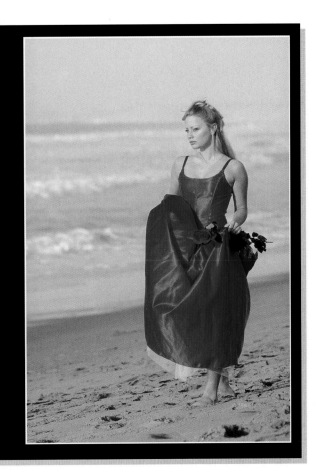

Image 9

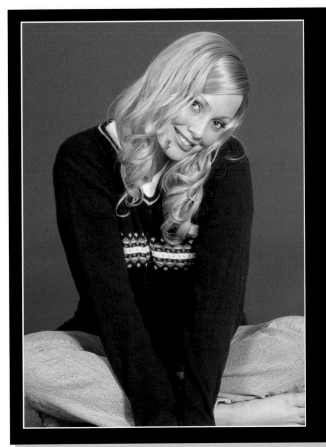

Image 10

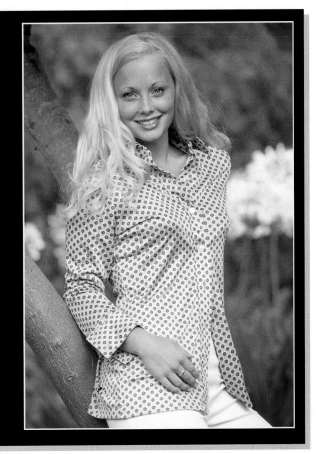

Image 11

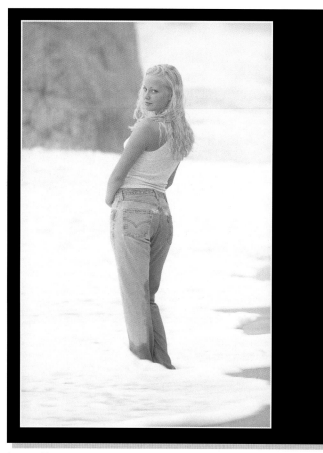

Image 12

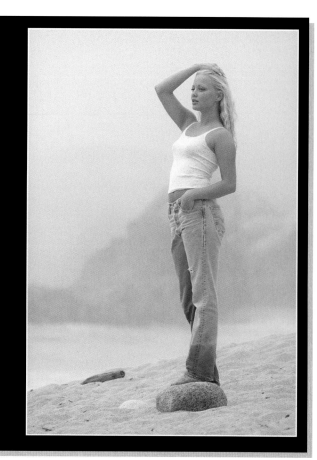

Image 13

[BLANK PAGE]

CLIENT'S
LOGO OR
NOTES ON
MODEL'S BEST
FEATURES (HERE,
GREAT LEGS)

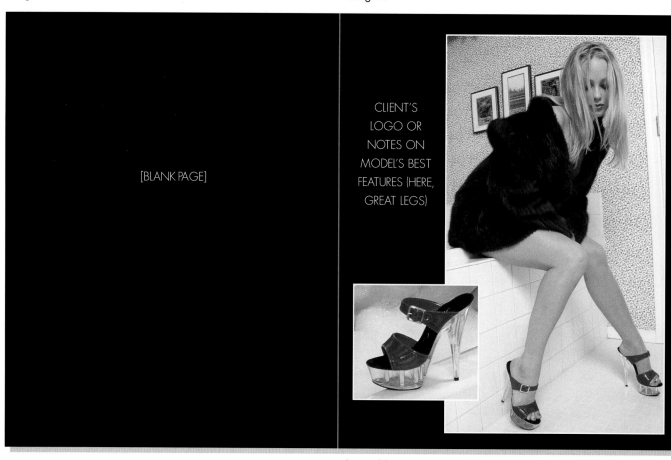

Image 14

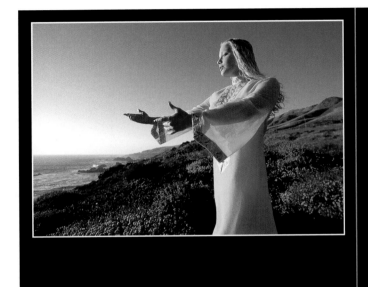

Image 15

Image 16

[BLANK PAGE OR MODEL'S RESUME]

Image 17

Image 18 (back)

ANDRA'S PORTFOLIO—IMAGE CAPTIONS

Andra—Image 1

Overview: With the late-afternoon sun filtering through the trees, I had an assistant hold a silver reflector underneath the model's chest in order to kick as much skylight as possible into her face.

Purpose: The Asian market loves clean and fresh head shots. Models need at least one simple shot like this so the client can tell what the model really looks like—not just how great the photographer is.

Special: It is important to keep your lighting systems and setup as simple as possible when working with beginning models. When models are new to their job in front of the camera, they will need the help of the photographer to direct them and provide support. Since you'll need to focus on this role, you won't want to be distracted by complicated lighting setups.

Specs: Exposure—$\frac{1}{30}$ second at f5.6; Lens—200mm; Reflector—42-inch silver circular Photoflex reflector.

Andra—Images 2 and 3

Overview: This photo was shot on location during a thunderstorm in Arizona. From time to time, the sun broke through the clouds just enough to kick up onto the model's face. The light was constantly changing, though, and when it went behind the clouds, the exposure would drop to $\frac{1}{8}$ second at f8. As a result, the model had to stand totally still. I had hoped to be able to photograph her on the horse, but there was simply not enough light to capture a crisp shot. These two shots were captured during moments when the sun broke through.

Purpose: The agencies in the Asian market like the Western look, and this image was created to appeal to that.

Specs: Exposure—$\frac{1}{60}$ second at f8; Filter—Tiffen warming filter; Lens—200mm.

Andra—Image 4

Overview: Here you see a casual look with jeans and a sweater. This image was shot in a field in front of the model's home as sunlight filtered down through the trees. I had the model back up so that the sunlight just

barely struck her shoulders. Two circular silver Photoflex reflectors were then placed to either side of her, and the camera was positioned to shoot between them. Note that the reflectors were not placed at the same distance from the model on each side. Instead, each was positioned where it would pick up the maximum amount of light.

Purpose: The image was included in order to show that the model would be excellent in a commercial catalog shoot for casual wear.

Specs: Exposure—¹⁄₆₀ second at f5; Lens—300mm.

Andra—Image 5

Overview: This photo was shot late in the afternoon, just as the sun was going down beneath the horizon. After photographing this outfit as part of the preproduction photos, I happened to drive by this field and notice how similar the patterns and colors in it were to those in the model's outfit. I went back to the studio and, after reviewing the preproduction photos, set up the shoot for the same time the next day.

Purpose: Again, I wanted to show that the model could work with clothing and would be good in a commercial catalog shoot.

Specs: Exposure—¹⁄₁₂₅ second at f8; Lens—300mm.

Andra—Image 6

Overview: This image was shot in a swimming pool while we were on an unrelated location shoot in Phoenix, AZ. Because the pool was in shade from the building, a silver reflector was used to kick light back into the model's face.

Purpose: This is a beauty shot, but without heavy makeup. We added braids in her hair to give it more of a

prepared look (not a grab shot), but her beauty is natural. The Asian market loves this clean and fresh look. Agents will always tell you to make your models look "clean and fresh—just off the porch in Iowa."

Specs: Exposure—¹⁄₆₀ second at f5.6; Lens—200mm; Reflector—42-inch silver Photoflex.

Andra—Image 7

Overview: This image was metered outside in filtered sunlight, then shot using a White Lightning strobe to match the exposure on the model with that of the sunlight. This ensured that the background wouldn't overpower the model. I placed the strobe's 42-inch silver umbrella as low as I could and shot under it. The umbrella was positioned with a slight downward angle to create a shadow underneath and behind the model.

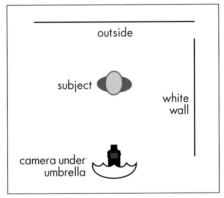

Purpose: I wanted to show a casual look, but this also provided a perfect opportunity to show off the model's hands and feet. Correct placement of the hands is so important in a photograph, and beginners have a very hard time with this. You'll need to carefully evaluate the model's hands, looking for (and eliminating) any signs of tension in their posing.

Specs: Exposure—¹⁄₆₀ second at f11; Lighting—White Lightning Ultra 1200 with 42-inch silver umbrella;

Lens—105mm; Meter—Minolta Flashmeter 3.

Andra—Images 8 and 9

Overview: This photo was taken in the late afternoon as the sun was going down. I rented a car so it would coordinate with the model's dress. I made sure the model was facing the sun, and I exposed for the highlight. It works great to have the clothing at a 90-degree angle to the direction of the sun because it adds texture—but you don't want texture on the model's face, so she must be turned toward it.

Purpose: These are good shots to show elegant, catalog-type work for the Asian market. Each model must have a wide range of looks, and shots like this help fill that need.

Specs: Exposure—¹⁄₆₀ second at f11, and ¹⁄₆₀ second at f5.6; Lens—300mm).

Andra—Image 10

Overview: This image was shot in the studio against a solid blue background. This allowed us to easily eliminate the background on the computer so we could use the photography in letterhead and other marketing materials.

The Nikon FE-2 camera syncs at ¹⁄₂₅₀ second, but I prefer to shoot at ¹⁄₆₀ second. That way, even if I accidentally hit the shutter speed setting during the shoot, I'll still get a usable exposure. It's important to get in the habit

of checking your exposure setting—especially after you have reloaded the camera, since that is usually when you will accidentally change it. You should also be careful to reset the aperture when you change lenses.

Purpose: Again, the Asian market loves this cute, all-American look.

Specs: Exposure—$\frac{1}{60}$ second at f11; Lens—135mm.

Andra—Image 11

Overview: This image was shot in the shadow of a tree with a silver reflector kicking light back onto the model. I used a 300mm lens to eliminate the office buildings in the background.

Purpose: A fresh catalog shot for the Asian market.

Specs: Exposure—$\frac{1}{30}$ second f5.6.5; Lens—300mm.

Andra—Images 12 and 13

Overview: We shot this photo in the early morning, on a day when the sky was very overcast. The idea was to create a conservative body shot with jeans and a t-shirt. I wanted to show the model's flat tummy and well-shaped bottom, but to be subtle about it.

Purpose: These were created for the Asian market as an example of the model's casual look, but she could also use the same photos to promote herself to jeans manufacturers.

Specs: Exposure—$\frac{1}{60}$ second at f5.6; Lens—300mm.

Andra—Image 14

Overview: Whenever you have the opportunity to show a model's special features, try to incorporate them in such a way that a client will be able to visualize the model wearing or using his products. You may even want to do a "layout," showing a tight shot of the model with a product. For this image, umbrella light was bounced off the ceiling to fill the bathroom.

Purpose: This photo illustrates the model's potential to do commercial catalog work.

Specs: Exposure—$\frac{1}{60}$ second at f8; Lens—35–70mm at 35mm.

Andra—Image 15

Overview: Late afternoon sun was the light source for this image. From shooting the preproduction photos, I understood how important the sleeves were on this outfit. I used a 20mm lens to create a dramatic angle and show a lot of depth of field.

Purpose: This image was used to add some drama to the model's portfolio, showing she could do something besides catalog work.

Specs: Exposure—$\frac{1}{60}$ second at f11; Lens—20mm.

Andra—Image 16

Overview: I used late afternoon sunlight to create this "pretty" picture. This is where the model's dance training helped add feeling to the image. I found this antique slip in a thrift store, but when shooting for a model's book, the clothing is secondary—what is important is the feeling a model brings to the shot and how she uses the clothing.

Purpose: This romantic image shows the mood the model can bring to a photo. It's similar to an editorial fashion shot.

Specs: Exposure—$\frac{1}{60}$ second at f5.6; Lens—300mm.

Andra—Image 17

Overview:

I shot this image from a hotel balcony under bright sunlight in hot Palm Springs. Then, I used Photoshop to take out the line at the bottom of the pool, cleaning up the image.

Purpose: I created this image as a non-sexy body shot for use in the Asian market.

Specs: Exposure—$\frac{1}{250}$ second at f11.

Andra—Image 18

This is the same as image 1, but it's not cropped as tightly.

ANDRA'S EXTRA IMAGES

When a model targets her portfolio for a certain market, she will have to eliminate any of the photos that are not appropriate for that market.

Andra does local work and loves to do a sexier look in this market. The sexy/poster look is not appropriate for the Asian market—or even for certain local markets.

Because of this, a model is constantly swapping photos in and out of her book in order to give herself the best chance of getting the job.

Andra—Images 19 and 20

Overview: Both of these photos were shot on location in a shallow river, but image 19 was shot in bright sunlight in

order to stop the action of her running. For this shot, I had the camera on a tripod and asked the model to run at the camera. Image 20 was shot in the same location as the shadow area of image 19 (see the upper-right corner of image 19). It is a pose that implies movement, creating a sense of action and freedom in the shot. To

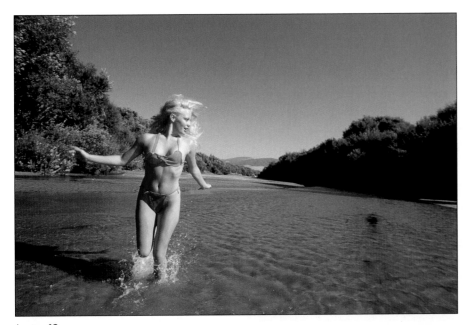

Image 19

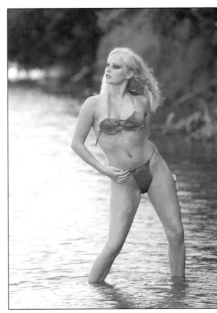

Image 20

emphasize this, I made sure to give the model some space for her to move into.

An important element in shooting a model is being aware of the opportunities that are provided at the location. The running shot was taken with a wide-angle lens (20mm) to provide more of an overview of the location and background. The posed shot was taken with a 300mm lens to separate the model from the background. Notice how different each shot looks at the same location. Be sure that, in bright sunlight, the model faces the sun so the light is evenly distributed on her face.

Purpose: The model made this outfit herself, and we used it to create a primitive Tarzan/Jane look.

Special: When posing a model (unless she is very slender), don't have her legs locked and facing straight at the camera—it will make her look heavy.

Specs: Image 19 Exposure—$\frac{1}{250}$ second at f11; Lens—20mm. Image 20 Exposure—$\frac{1}{60}$ second at f8; Lens—300mm.

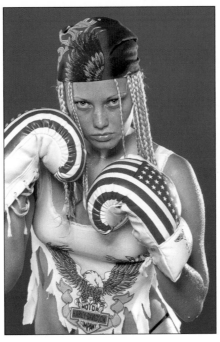

Image 21

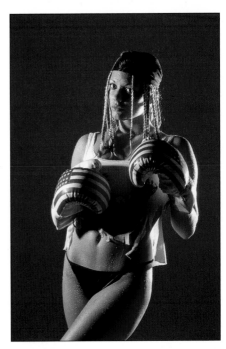

Image 22

Andra—Images 21 and 22

Overview: We shot these images in the studio against a solid blue backdrop, so we could later use Photoshop to drop in another background of our choosing.

Purpose: In these shots, I wanted to show the model's range of facial expressions and her flat stomach.

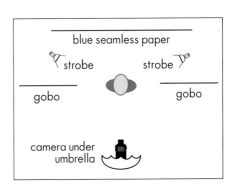

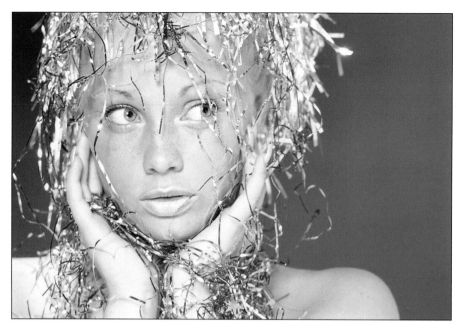

Image 23

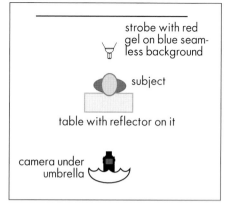

strobe with red gel on blue seamless background

subject

table with reflector on it

camera under umbrella

Purpose: This type of image lets the studio team have fun and creates a vehicle for the model to show facial expressions.

Specs: Exposure—$\frac{1}{60}$ second at f8; Lens—135mm. Exposure 25—$\frac{1}{60}$ second at f8; Lens—200mm.

Andra—Images 26
Overview: This image was shot in the late afternoon under hot sun in Phoenix, AZ.

Purpose: The model wanted to create a look similar to a Guess?® ad, with a Western flare.

Specs: Exposure—$\frac{1}{250}$ second at f8; Lens—300mm.

Andra—Images 27 and 28
Overview: Late afternoon sunlight coming through a kitchen window and hitting the floor was the source of light for this image. My photo assistant used a gold reflector to pick the light up and reflect it back onto the model. Be careful when lighting from underneath the model—she must be looking down to fill her face with light. If you don't fill the mask of her face with light, you can end up causing the old horror-movie bottom-light effect.

Purpose: We wanted to produce a lingerie shot that had impact and glamour.

Specs: Exposure—$\frac{1}{15}$ second at f5.6; Lens—105mm.

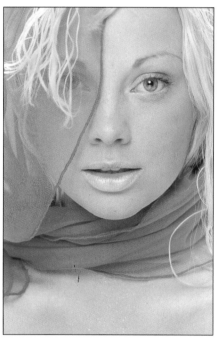

Image 24

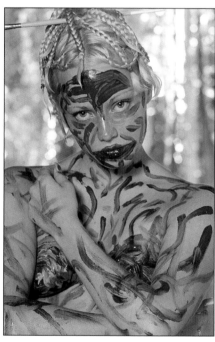

Image 25

Specs: Exposure—$\frac{1}{60}$ second at f8, Lenses—200mm and 85mm.

Andra—Images 23, 24 , and 25
Overview: Tight headshots add some dramatic impact to a portfolio—and shots like this let the makeup artist play, too! The makeup artist gets a chance to create something he can use in his own portfolio, and the model feels good about creating an image that others don't have. She sees herself as she would see models in magazines. These "play" shots are fun but will have limited value in her portfolio. Major agencies want to see the model's potential more than your artwork.

Image 26

Image 27

Image 28

Image 29

Image 30

Andra—Image 29

Overview: Late afternoon sunlight was used to create this feminine image of the model in a vintage slip. For details, see the information provided for image 16 (page 70).

Specs: Exposure—1/60 second at f5.6; Lens—300mm.

Andra—Image 30

Overview: The late-afternoon sun had already gone down, and the model was ready and practicing her poses at this location while I was waiting for the sun to kick some color back onto the beach. Blue material was wrapped around the model and allowed to drag into the water and wash against her legs.

Purpose: We wanted to create a post-card-type shot that both the photographer and the model could use for their own marketing purposes.

Specs: Exposure—1/30 second at f8.

7. Laine's Portfolio

■ ABOUT LAINE

I met Laine while shooting on location for an agency in Canada. We had a wonderful photo session and later went to dinner to discuss her career. I invited her to visit my studio in the USA, and to work on this book project. About six months later, Laine came to visit for a few days.

Laine had already been working as a model, as a result of our first photo session plus a couple of sessions with another photographer. She had decided to advance her career, so she came to visit to work on her portfolio. We shot for a couple of days to produce a variety of looks—plus a new promotional piece. Since Laine had already been working as a model and had an agent, we didn't do profile shots. Instead, we targeted a few photographic concepts and looks that would help her market herself internationally.

We targeted a few photographic concepts and looks that would help her market herself internationally.

Laine has the height to work in markets such as New York or Europe, but she chose to work in the Asian market because she could begin working immediately without having to reshoot her book and restructure her look before entering the workforce.

■ VARIETY

A model should work with several photographers and have their work in her portfolio. A model's portfolio is never finished. She is always adding and subtracting photos, due to style and seasonal changes. Each photographer has his/her own style and can add variety to a model's book. After my studio team and I have helped the model develop a basic book and some knowledge and confidence, we recommend she shoot with several other photographers. Our job is to help her get started in the business.

Hopefully, she will someday replace all the photos in her book with work from paid jobs (called "tear sheets").

■ THE PORTFOLIO

In order to preserve their grouping, the following five pages contain Laine's portfolio. Beginning on page 81, you'll find discussions of these images. These discussions tell you how the photos were made and why each photo was included in Laine's portfolio. Using this information, you'll begin to see the thinking that goes into every step of marketing a model to her desired customers.

You'll begin to see the thinking that goes into every step of marketing a model to her desired customers.

For a model who has the potential to work in the European or New York market, your job as a photographer is to get her enough photos to be considered by a major agency. Once she is signed, her book will probably be reshot for their particular market and clients.

For this reason, Laine's portfolio was not shot as a working portfolio (she can use it as such, though). Instead, it was created as a tool for her to use when seeking representation from international agencies. The goal was simply to show off her potential and beauty. Because this was the case, her portfolio didn't need to be as extensive as the one that was created for Andra (pages 63–68). That said, though, Laine did work extensively in Japan during the year following its creation.

Image 1 (front)

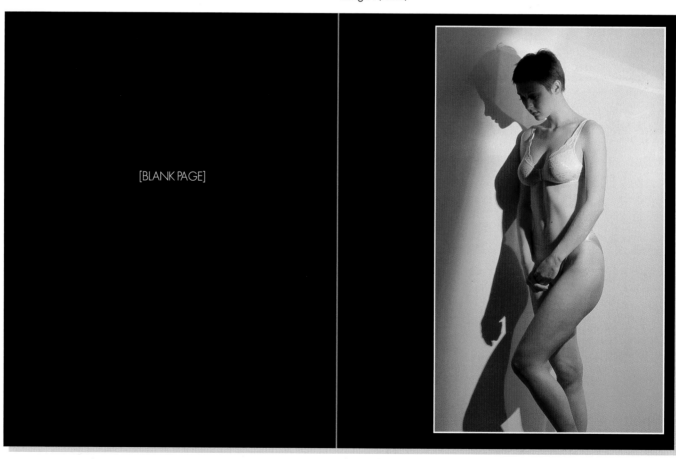

[BLANK PAGE]

Image 2

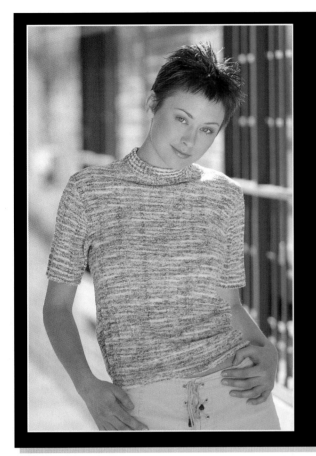

Image 3

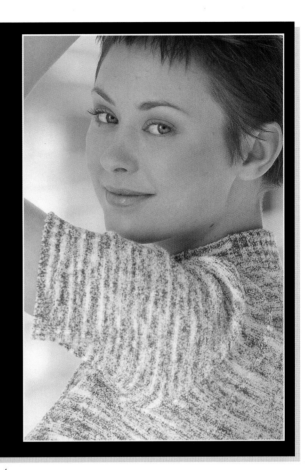

Image 4

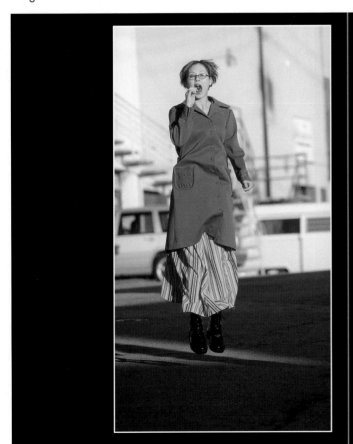

Image 5

Image 6

Image 7

Image 8

Image 9

Image 10

Image 11

Image 12

Image 13

[BLANK PAGE]

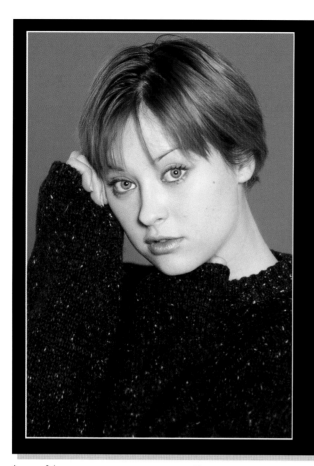

Image 14

[BLANK PAGE]

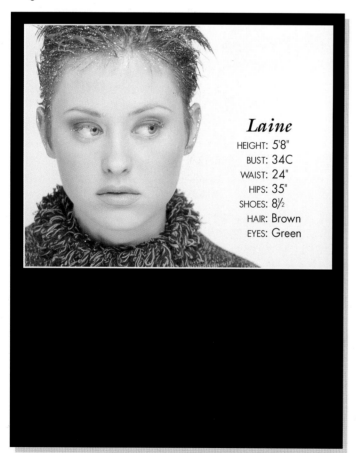

Laine

HEIGHT: 5'8"
BUST: 34C
WAIST: 24"
HIPS: 35"
SHOES: 8½
HAIR: Brown
EYES: Green

Image 15 (back)

Laine—Image 1

Overview: This tight headshot was used to add interest and impact to Laine's portfolio. She came in with this sweater on. I liked the collar but not the sweater, so she put it on backwards and we pinned the collar tight to add a dramatic effect. We shot the photos several different ways for her to use in her marketing materials. The makeup artist was told to "play" and give me something wild to go with the collar of the sweater.

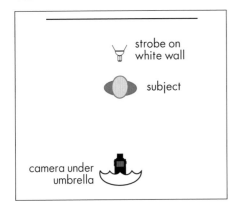

Purpose: We wanted to create impact shots for use in the model's portfolio and promo cards.

Specs: Exposure—$\frac{1}{60}$ second at f8; Lens—135mm.

Laine—Image 2

Overview: I shot the image indoors, using a large mirror to bounce the light and create a pattern. A Tiffen warming filter was used the create an interesting color. Notice how the shadows emphasize the contours of the model's body.

Purpose: Laine is not comfortable being sexy, but she is comfortable with her body and will shoot lingerie (to sell the product, not sex). Therefore, we created this non-sexy body shot that can be used to show the model's proportions. You must always be careful when working with a new model—don't try to create photos that will misrepresent the model or her comfort level.

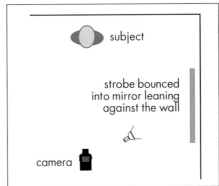

Sometimes I use a video camera and record a mock session, then play it back for the model so she understands what I see and what we are trying to accomplish. After a few photo sessions, she will start to understand the importance of controlled movement and that the background has very little to do with the style of the photograph. Alternately, if you shoot digitally, you can review the images with the model on your computer screen or your camera's LCD. This is an effective teaching tool when you are trying to illustrate a point about posture, cropping, and controlled movement.

Specs: Exposure—$\frac{1}{60}$ second at f5.6; Filter—Tiffen warming filter.

Laine—Images 3 and 4

Overview: This was shot on a cold, clear day in northern Canada. Bright sunlight illuminated the scene, but the model was placed in the shadow of the building. I used a silver umbrella to kick light back into the model's face.

Purpose: We wanted to create an image with a commercial look.

Specs: Exposure—$\frac{1}{60}$ second at f5.6.5; Lens—200mm.

Laine—Images 5 and 6

Overview: Both images were created using late afternoon sunlight. Image 5 was shot in direct sunlight, which was necessary to stop the action of the model jumping in the air. Image 6 was shot with the same outfit and with the same model, but the photo has a totally different feel because it was shot in the shade of a building.

Purpose: We wanted to create a fun look for the model's portfolio.

Specs: Image 5 Exposure—$\frac{1}{250}$ second at f8; Lens—300mm. Image 6 Exposure—$\frac{1}{30}$ second at f5.6.5; Lens—200mm.

Laine—Images 7 and 8

Overview: Even though the outfit is the same, moving in tight on a shot easily created two distinctly different looks. These images were paired and placed in the portfolio so that seeing Image 8 forces the viewer to look at Image 7. Pay special attention to the model's hand position when creating a tight headshot like this—a natural, relaxed position is critical to the success of the image. Both of these images were shot using late afternoon sun.

Purpose: We intended to create a body shot in this particular dress. Then, as the light was going down, I loved the warm play of light on Laine's face.

Specs: Exposure—$\frac{1}{60}$ second at f8; Lens—200mm.

Laine—Images 9 and 10

Overview: Here, you see two studio shots using basic umbrella lighting. These photos, though not as glamourous as many, will do more for a model's career at an early stage than any other will. They show potential

agents and clients what her skin is like and the beauty of her face. Simple compositions and angles are all that is needed. Be careful not to select a distracting background, since this can take the viewer's eyes from the model's face.

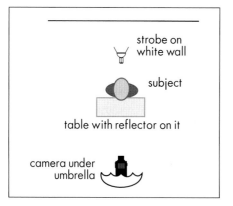

Purpose: This image demonstrates the clean and fresh look that is appropriate for the Asian market.

Specs: Exposure—$\frac{1}{60}$ second at f8; Lens—200mm.

Laine—Image 11

Overview: This image uses the same lighting setup as discussed in images 9 and 10.

Purpose: We wanted to create an image with more of a fashion/glamour style to go with images 9 and 10 in the model's book. This helps to show her versatility and contrasts the two beauty styles.

Specs: Exposure—$\frac{1}{60}$ second at f8; Lens—200mm.

Laine—Image 12

Overview: It was a very cold day out—only 20°F—when we created this image under bright sunlight. Silver reflectors were placed on each side of the camera to kick the available light onto her outfit. I shot the image with a 300mm lens in order to stack the light poles and draw the viewer's eye to the model. I also left enough room on the righthand side of the photograph to add copy for the dress designer's promotion.

Purpose: This image was shot as a promotional piece for the clothing designer, and a fashion photo for the model's portfolio.

Specs: Exposure—$\frac{1}{30}$ second at f8; Lens—300mm.

Laine—Images 13 and 14

Overview: For this studio shot, which employed a main light and a hair light, the exposure reading on the blue background was f5.6. On Laine's face, the reading was f8. The hairlight exposure was f11.5.

Purpose: We wanted to create headshots in two totally different styles in order to show the model's beauty and versatility.

Specs: Image 13 Exposure—$\frac{1}{60}$ second at f8; Lens—200mm; Lighting—Silver umbrella main light in front of model, hairlight over model. Image 14 Exposure—$\frac{1}{60}$ second at f4; Lens—200mm; Lighting—Silver umbrella main light in front of model, hairlight over model.

Laine—Image 15

The last photograph in a portfolio can sometimes be used as a promotional piece. This one works well for that purpose, because the portfolio viewer has seen her range as a model and now they can easily refer to her statistics. This photo works well because the model's eyes force the viewer to look to the right.

8. Jenna's Portfolio

■ ABOUT JENNA

Jenna walked into my office after being referred by a friend of hers who had seen my portfolio while I was shooting on location. We talked for a while about modeling, what it takes to make it, and what her goals were. She was a sweet young woman of sixteen at the time and a junior in high school. I gave her a goal sheet and asked her to go home and put together a mock portfolio, then come back the next week with her mother.

I also asked her to bring a roll of color print film and a two-piece bathing suit, so we could create a series of profile shots and take her measurements (see pages 18–23 for more on this process). She returned with her mother the following week, and we discussed the business, her potential, and went over her mock portfolio. We then worked on Jenna's profile shots and took her measurements. She processed the film and returned the following week.

I gave her a goal sheet and asked her to go home and put together a mock portfolio, then come back the next week with her mother.

At this point, we decided that it would take her about six months to get ready to market herself. Jenna, her mother, and I discussed the fact that it seemed to be in Jenna's best interest to work locally until she graduated from high school. (Remember, our responsibility as photographers is to help the model achieve her goals and to photograph her in the manner that most benefits her.) Jenna then visited a local hairstylist that I work with. She had her hair trimmed and was put on a maintenance program. She also decided to lose a few pounds and to work on toning up.

When she was ready, we structured her portfolio with commercial shots for the local market. A commercial shot is one where the product is the main focus of the photograph and the product is highly visual (see images 2, 3, and 14). This is in contrast with fashion or editorial images,

where the exact product being sold is sometimes left to the viewer's imagination. Image 11 could also be commercial, if it was used in a catalog, and image 12 could be classified as commercial, because it was used in a hair salon advertisement. Without text from the salon, however, it has more of an editorial feel.

We also shot a few photographs Jenna could market to the major agencies in New York and Los Angeles. After she had gotten her hair and body in the best possible condition, we also reshot the profile shots so we could send them out with her portfolio in a promotional package.

One special note about Jenna is that she is a very talented actress. The commercial shots can—and will—help her in her pursuit of success in that field.

■ SPECIAL FEATURES

A model's portfolio should highlight her unique assets. As an actress, Jenna can show a wide range of facial expressions and moods. To emphasize this, we used a combination of photographs— each of which shows something special about her. Even though the props are the same in each image, combining the images forces the viewer to look for differences—in this case, Jenna's expressions. Showing her with a product can help the clients visualize how she would look using their products. The last shot in the book should also remind the viewer of the model's strength—in Jenna's case, this is the ability to show emotions.

Showing her with a product can help the clients visualize how she would look using their products.

■ THE PORTFOLIO

In order to preserve their grouping, the following five pages contain Jenna's portfolio. Beginning on page 89, you'll find discussions of these images. Unless otherwise noted, all the photos for Jenna's portfolio were shot on Kodak Elite ISO 100 slide film (rated at ISO 80). A Nikon FE-2 camera and Nikkor lenses were used. I always shoot on a Bogen tripod (unless otherwise noted) and use a handheld meter (Minolta Flashmeter 3 or Gossen Luna Pro). The black & white images were shot on Kodak Plus-X 125.

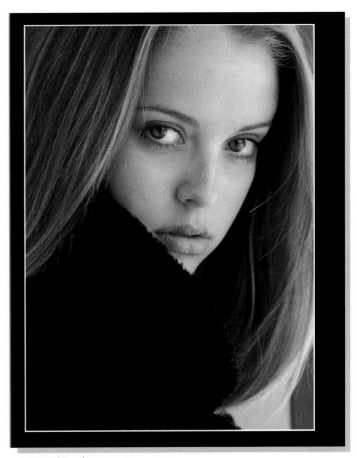

Image 1 (front)

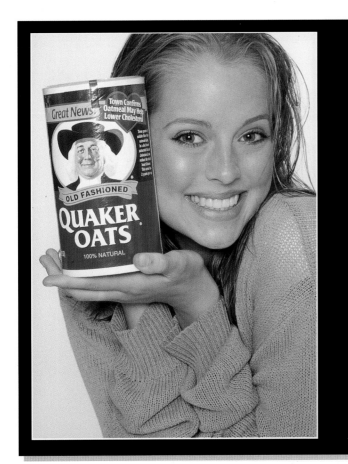

Image 2

Image 3

Image 4

Image 5

Image 6

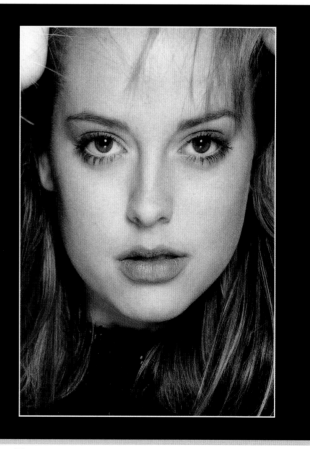

Image 7

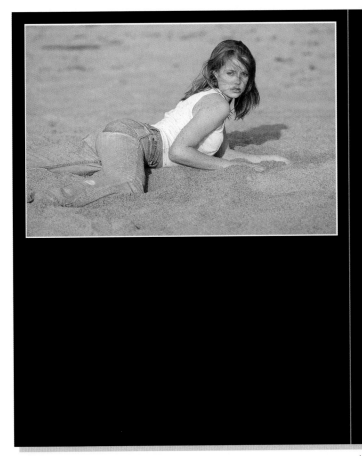

Image 8

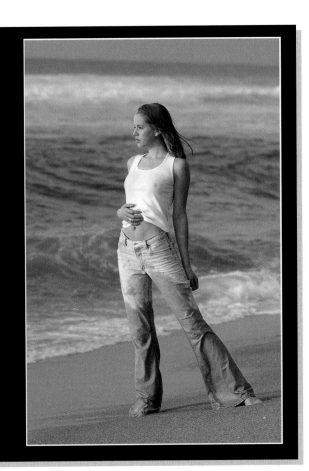

Image 9

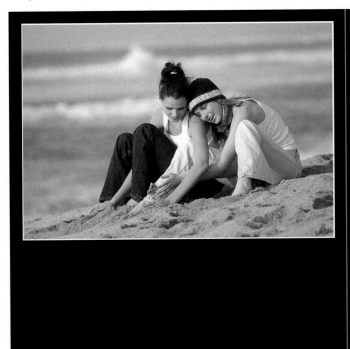

Image 10

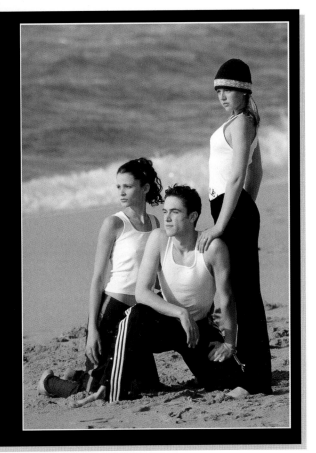

Image 11

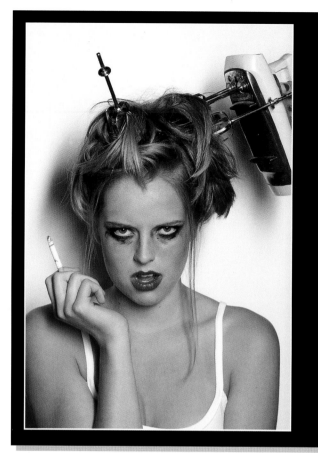

Image 12

Image 13

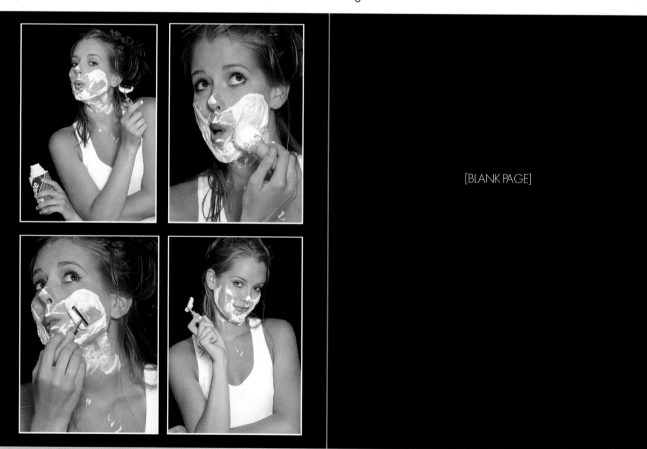

[BLANK PAGE]

Images 14a–14d

Image 15 (back)

JENNA'S PORTFOLIO—IMAGE CAPTIONS

Jenna—Image 1

Overview: It was a bright day and light was bouncing off the windows of one building and striking the wall of an adjoining one. I placed the model in the reflected sunlight. The model was leaning against the wall and looking into the camera. We had to shoot tight headshots in this area, because the pattern of light was quite small.

Purpose: We wanted to create a beauty shot with the model wearing very little makeup.

Specs: Exposure—$\frac{1}{30}$ second at f5.6.5.

Jenna—Images 2 and 3

Overview: All of these shots were created using the same simple studio lighting employed in images 13 and 14 from Laine's portfolio (see page 82).

Purpose: Jenna is an actress, and she has a wide range of facial expressions. She was limited, however, to working in her local market until she graduated from high school. Because of this, we decided to shoot a few commercial-style product shots to demonstrate her acting ability.

Specs: Exposure—$\frac{1}{60}$ second at f11.

Jenna—Images 4 and 5

Overview: Beautiful late-evening light was streaming through the shutters when we created this image. I positioned the model in front of the window and opened the shutters behind her to give continuity to the scene. Without the shutters open, the viewer's eyes were forced to look at the background. A white reflector board was placed close to the model's back to reflect light onto it and fill in the shadows. Image 5 was lit and posed in the same way as 4, except that we added her girlfriend to the image to create a "sisters" look.

The coloration change in image 5 was due to a piece of interesting paper that we had gotten on a bouquet of flowers. I cut a square out of the paper and held it in front of the lens. The paper was twisted and positioned so that only part of the lens was covered. I kept the same meter reading as in photo 4, but then also bracketed. As it

turned out, the frame at the same exposure as 4 worked the best. Even though it was a little darker, the dark tone actually added to the mood of the photo.

Purpose: We wanted to create a non-sexy body shot, and a moody shot with the model's friend.

Specs: Exposure—1/30 second at f8; Lens—85mm.

Jenna—Image 6

Overview: This image was shot in a large warehouse using simple, one-umbrella light. The background walls were far enough back to drop off to black.

Purpose: We wanted to create a pretty half-body shot that showed the model's flat stomach. (While it wasn't needed in Jenna's case, posing the model with her shoulders against the wall and her buttocks away from it helps to stretch out her tummy and give her a flatter stomach.) During a model's first photo shoot, you must give her the simple, fresh shots that she will need to market herself. However, I also like to give the model a few shots that will really make her feel good about herself.

Specs: Exposure—1/60 second at f8; Lens—105mm.

Jenna—Image 7
See information for Image 2.

Jenna—Images 8 and 9
Overview: Late afternoon light was used for this image, which was shot on the beach in Monterey, CA. We had about half an hour to complete these four shots. In situations where the sunlight is moving, you must continually ensure that your model is facing into the light. Because the sun was low on the horizon, its light filled in all the shadows on the models' faces.

Purpose: We wanted to photograph Jenna with a couple of other models in order to show her interaction with them and to create images with a commercial look.

Specs: Exposure 8—1/125 second at f8; Exposure 9—1/60 second at f8.

Jenna—Image 10 and 11
Overview: Images 10 and 11 are a good addition to a model's book because they show that she can work well with other models. Many commercial product shots feature multiple models, and the models do need to learn how to interact with and work with others—even if they are strangers.

Specs: Exposure 10—1/125 second at f8; Exposure 11—1/60 second at f8.

Jenna—Image 12
Overview: This image was created on location at a hair salon. The model was positioned against a white piece of reflector board with egg beaters in her hair and a mixer. We placed heavy eyeshadow under her eyes and asked her to cry. This caused the eyeshadow to smear and gave us the messed-up look we wanted.

The idea was to create a "snapshot" look—as if you were in her kitchen. Therefore, we positioned a White Lightning strobe (using a normal reflector covered with diffusion material) a little above and to the right of the model. The shadows this created imitate the results you get with an instamatic camera.

Purpose: We needed to create an ad shot for a funky hair salon. It ran with text that read, "Tired of getting whipped and beat up?"

Specs: Exposure—1/60 second at f8; Lens—135mm.

Jenna—Image 13
See information for Image 2.

Jenna—Images 14a–14d
See information for Image 2.

Jenna—Image 15
See information for Image 1.

9. Frequently Asked Questions

When you are working with new models, you'll find that they have a lot of questions about the industry they are about to enter. The following are some of the common questions that models and photographers who are new to the field of model photography may have about the business. To give the best answers to these questions, I conducted interviews with several professionals. These are:

- **Loa Andersen** (Seattle, WA), a former model, agent, and now a modeling consultant.
- **Tom Gusway** (Vancouver, BC; Las Vegas, NV; Los Angeles, CA), an agent and modeling consultant. For more information, visit www.modelmgmt.com or www.lloydtalent.com.
- **Dan Grant** (Toronto, ON), an agent. Visit him at www.grant-models.com.
- **Cody Garden** (Las Vegas, NV; Los Angeles, CA; Salt Lake City, UT), an agent. For more information, visit www.mccarthytalent.com.

■ WHAT MAKES A GOOD MODEL?

What is the difference between a model and a talent?

Fashion models are primarily fashion-oriented and do glamour work for television, editorial, and fashion print, plus live runway work for shows. Commercial models do product-oriented print work. Talent also does product-oriented print work and television commercials. Models are generally tall, young, and beautiful; the talent category includes every age, appearance, and gender—from the baby who advertises diapers right through the little old lady promoting a retirement center.

How do I know if I'd be a good model?

Be realistic. Take a good long look at yourself in a full-length mirror and be honest. Examine your features and figure critically. Consider your family and friends. Do you have their emotional and/or financial support in your endeavors? Do you have someone to turn to for comfort when you are disappointed or frustrated? Modeling is a crazy business, and there are no guarantees. It is a very competitive business that requires total professionalism for the smallest of parts. It is not always glamorous, nor is it easy. The disappointments are many and the successes are few. However, if you approach the industry with your feet on the ground and an eye on your pocketbook, you can have some very positive experiences! There are times when it is exciting, fun, and even very glamorous.

What skills are necessary?

A model must be able to work the runway with confidence and grace, and with knowledge of the basic turns. A model also must be able to relate to the camera, showing a variety of different moods, emotions, and attitudes. He/she must also know how to move on-camera, so as to show their best features and hide their flaws. A talent must be able to act, especially for TV commercials. They will be asked to do cold reads, improvisations, and to relate to other actors. The talent also has to know how to "work" the camera lens. A good self-image, a strong but controlled ego, a lot of patience, common sense, and a good sense of humor are also nice qualities in both models and talents.

Where can one gain these skills?

For the talent, acting classes are important. Many community colleges have excellent programs, as do high schools. Volunteering for community theater productions will help one develop skills, as well. Also, some-

A model must be able to relate to the camera, showing a variety of different moods, emotions, and attitudes.

times local casting agents offer classes aimed toward developing new talent for television commercials and films.

For the model, experience is the best teacher. Watch fashion shows, see what steps are done, then go home and try them yourself! Read all the books in your local library about the industry. Some of what you read is hype, but you can still learn a great deal. Hire an experienced runway model to assist you. Many fashion photographers can also assist you in learning to work the camera for the price of a shoot. If all else fails, attend a reasonably priced workshop on basic modeling. Check schools and community colleges in your area.

Must one go to a modeling school in order to become a model?

Absolutely not! If you have what it takes to be a model, you will need very little training. If you don't have what it takes, no amount of training is going to make a difference. Don't spend a lot of money at a modeling school. Most of the models that I have represented have spent less than $200.00 total on training. This isn't to say that modeling schools are bad. Some teach good material regarding hair care, makeup, poise, and social graces, etc. Having these skills can assist a young person in becoming more self-confident.

Can children be professional models/talents?

Loa Andersen says that some of her top producers as an agent were under ten years old, and one started her professional career as a six months old in a national television commercial. If a child loves to perform and feels good about it, then she encourages the parents to test

For models, experience is the best teacher. Formal training isn't necessary, although it can help a model develop poise and learn about hair and makeup styling.

the waters. However, if the child is shy, feels stress, or takes rejection badly, then it is not a good idea. Before spending a lot of money getting pictures and signing with an agent, Loa suggests enrolling children in a program that gives them a taste of runway, print, and television production. From this experience, the parents can judge if they should continue in the field.

■ MARKETING MATERIALS

What materials does a model/talent need?

The marketing materials used by models and talent are called packaging. A model needs a portfolio, a book of pictures showing the model in a variety of poses, moods, and garments. The best four or five pictures are made into a card (often called a zed card or laser-composite card [see below]). Models generally have copies made of this card for distribution to local clients and international agencies.

Ashley

Height: 5'8" Weight:116 Bust: 34b Waist: 25 Hips: 34 Dress: 3 Shoe: 8 Hair: Brown Eyes: Green

MODELS INTERNATIONAL®

4170 S. Decatur #D-1
Las Vegas, NV. 89103
702-364-9246
MMODELS.com

A model's zed card features a few of her best images along with her measurements (height, bust, waist, hips, shoe size, dress size, etc.), hair and eye color, and the information that potential clients will need to contact her agency.

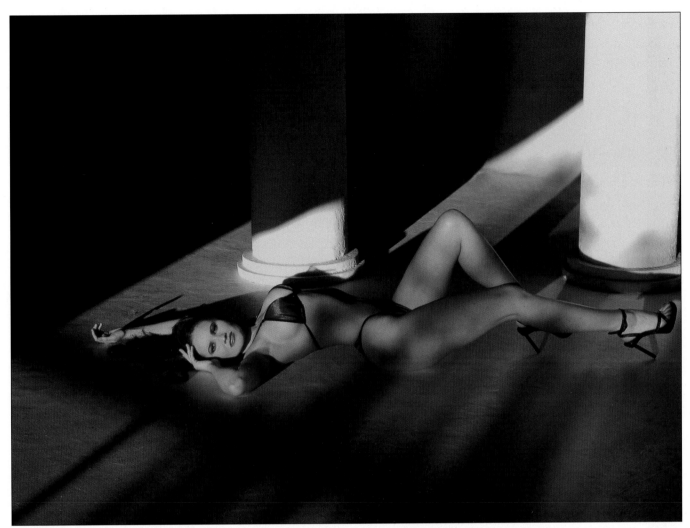

A good model must know how to move on-camera, so as to show her best features and hide her flaws.

Talents need only a basic commercial headshot, one picture that is then printed in batches of 100–300 with the talent's name and agency logo. The talent may have additional pictures on their card if they wish, but a basic headshot is sufficient to start. The talent then attaches a resume to the back of each card (often called a comp). The resume is a very important part of the talent's package and must be written carefully and in a rather standard form. Check with your agency for details.

What are zed and comp cards?

Traditionally models use a 6x9-inch card called a zed card. Many agents have a standard look that they like to maintain for their agency. Normally there is one photo on the front and three or four on the back. A comp card is used in the acting/talent side of the business, and is also referred to as a head shot. The size is normally 8x10 inches or 8½x11 inches, and a resume is stapled to or printed on the back. The ideal situation would be to have a zed card for modeling and three different comp cards—one with a headshot with very clean makeup, one with a three-quarter body shot with very little makeup, and one with a theatrical caricature shot.

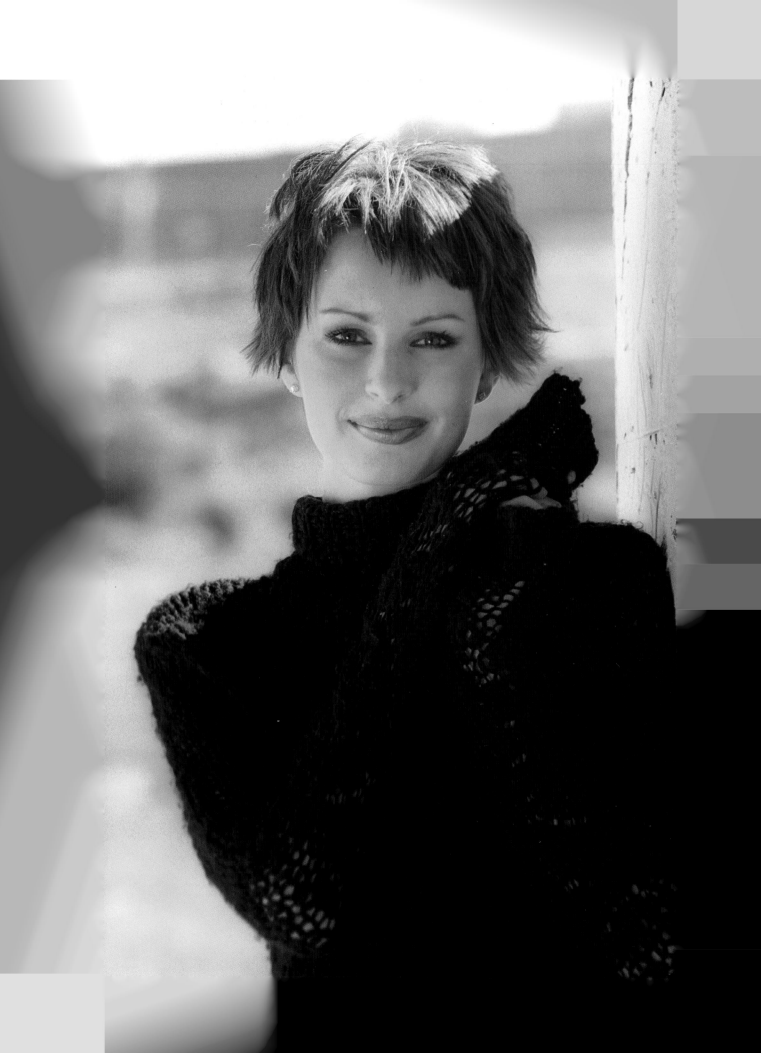

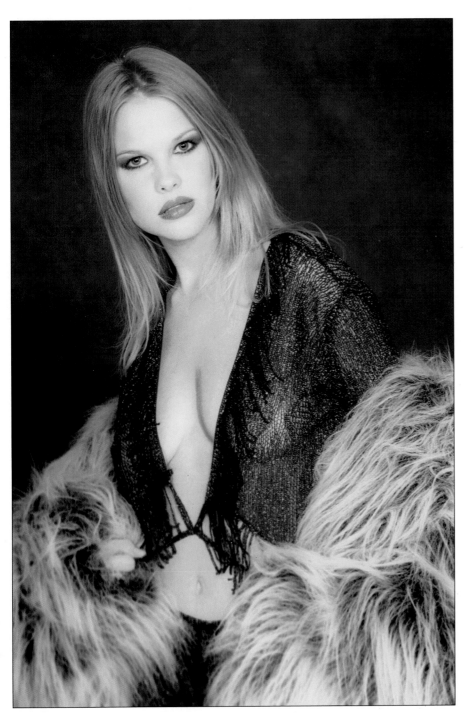

ABOVE AND FACING PAGE—Before hiring a photographer, a model must see his or her portfolio. If the work is good, she needs to make sure that the photographer can create the style of images she is looking for.

Then, the model/talent would submit the zed card or one of the three comp cards to the client, depending on which one best suits the style and requirements of the job.

How much should I pay for photos and comp cards?

The price the model will pay for her photographs should be negotiated between the model and the photographer. Beware of agents that offer package deals; you should always deal with the photographer directly. Comp-card and zed-card pricing should be negotiated with the printer. Most agents have printers they prefer to use because they have the agent's logo on file.

How do I put together a portfolio?

You need about 12–20 photos for a woman, or 6–12 for a man. The photos need to show your range (both in term of style and emotion) as a model. See chapters 6–8.

How do I choose the pictures for my portfolio?

When referring to the list on pages 34–38, pick five or six categories that you could see yourself working in, and make sure those categories are represented in your portfolio. For example, a great swimwear shot would show the model's tight legs, flat stomach, and a nice curvature of the chest.

What size photos do I need?

Most modeling agencies use either 8x10-inch or 9x12-inch prints. The larger, fashion-oriented agencies tend to use 9x12-inch prints because tear sheets from magazines will then fit in the same portfolio without having to be trimmed. Prints in the 8x12-inch size have now also become equally popular.

What do my photos go in?

Most agencies currently use specialized books that are designed specifically for models. They usually cost about $30–70. Nothing should be included in the portfolio other than photos and a resume or comp cards. Stay away from zipper-type artist portfolios.

Do I need to have work by multiple photographers in my book?

Most agencies have a select number of photographers that they use because they like their unique styles. By including a wide variety of styles in your portfolio, you can show your potential clients that you are very versatile. Remember that the whole reason for creating a portfolio is so that a potential client will hire you to work in their advertising campaign.

How do I find a photographer?

Most agencies have a list of recommended photographers. If you are not with an agent, call several agencies and ask them to recommend photographers in your area.

How do I know if a photographer is any good?

Ask to see their portfolios. Never shoot with a photographer until you have seen their work. Even if the work is good, you also need to know that they shoot the style that you are looking for. Are you comfortable with them? Again, the recommendation of your agent will be very useful.

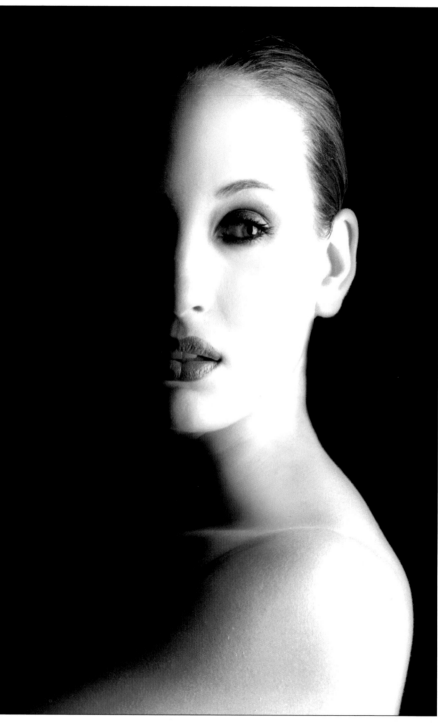

ABOVE AND FACING PAGE—Many models decide to use their images on a personal website, giving potential clients instant access to a wide variety of their images.

What happens after the portfolio is complete?

A portfolio is never complete—it is always a work in progress. You should constantly be updating your book with new photos and tear sheets. After your portfolio contains images that are a good representation of your

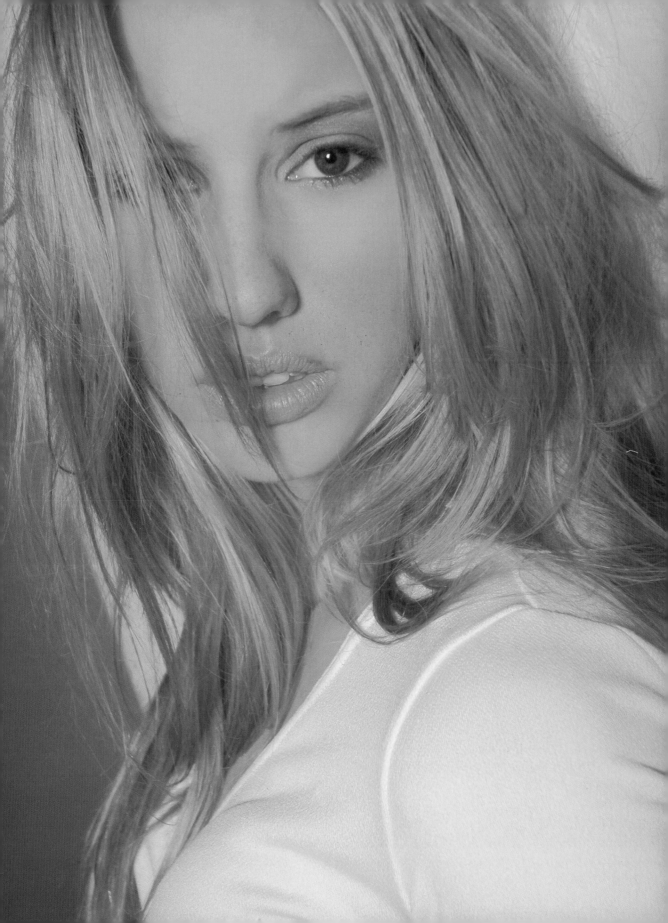

abilities, talk to your agent about their marketing strategy. If you do not have an agent, now would be the time to approach one. (Usually, it is better to start with an agent and then build your portfolio, because each agent knows their client's styles and tastes and how to market to them.) Review your portfolio and choose your strongest photos. These will be used to make your zed and/or comp cards. You may want to duplicate your portfolio and leave one with your agent.

Can I use a digital portfolio?

You can have your portfolio put on CD for easy and inexpensive distribution. There may be fees to cover the work involved in creating this

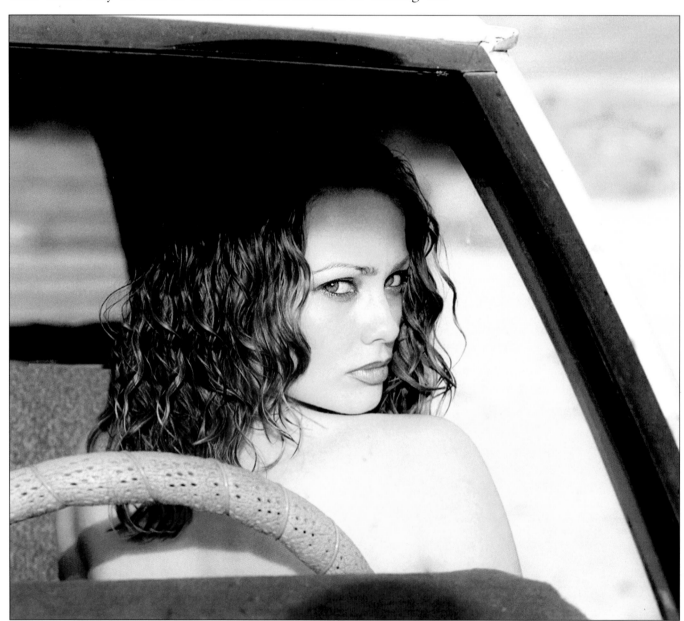

Agencies should never charge a fee simply to represent a model; the agency should be paid a percentage of her gross income from the modeling jobs they get her.

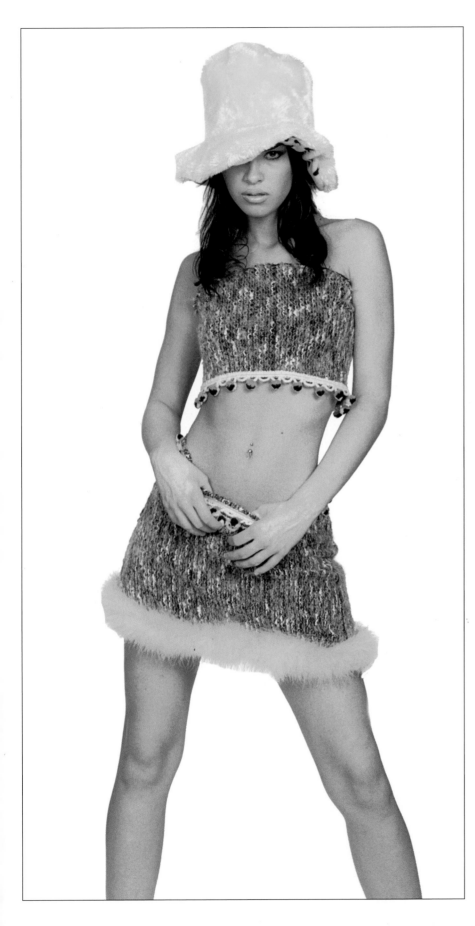

scanned version of your portfolio. Once your portfolio is digital, however, when clients ask for copies of your tear sheets and work, the agency can immediately send them high-resolution digital files for review. The client can then print them out themselves.

Do I need a website?

Websites are becoming the primary means of promotion for models, and it is essential that you participate in promoting yourself on a site. With your images and portfolios available online, an agency can drastically reduce the amount of messenger costs, shipping charges, and copy fees that you incur—and this can actually save you hundreds of dollars a year. Some agencies require that everyone who is represented be on the site and pay a yearly fee. This fee covers the scanning of your images, production involved in maintaining your online book, and periodic updates to your listing.

■ AGENTS AND AGENCIES
What exactly does a model/ talent agent do?

An agent represents models and talents for television commercials, print work (both fashion and commercial), commercial films, industrial films, voice-overs, and live runway jobs. The agency handles all financial negotiations and pay-

Getting work is a combined effort by the agent and the model. The biggest mistake that beginning models make is to sit back and do nothing after they have an agent.

ments, arranges auditions, serves as a glorified answering service, and guides the careers of their models/talents. For this, agents are paid a commission based on what the model/talent earns. In addition to the commission, some agencies have a one-time sign-up fee, usually not more than $25.00. Some (especially the big-name agencies in New York, Milan, Tokyo, etc.) require the model/talent maintain a minimum productivity (monies generated for the agency) in order to maintain representation with the agency.

RIGHT AND FACING PAGE—During the shoot, the model's responsibility is to try to communicate the feeling or style that the client is trying to portray in their product.

How do I pick a good agent?

Here are some important things to ask when you go to the agency for an interview:

a. How do you market your models?

b. How many people do you have in the agency?

c. How many people look like me?

d. What type of models do you represent in your agency—runway, fashion, etc.?

How do agents scout for new models/talent?

Agents are always on the lookout—everywhere they go! On trains or planes, in malls, schools, restaurants . . . everywhere. A reputable agent will *never* ask for your phone number or name. Instead, he or she will simply give you their card and say, "If you're interested in modeling, please give me a call." Don't give your phone number to just anyone who says they are an agent, and be especially wary of those who say they can make you a star.

How much do agencies charge?

An agency should never charge a fee simply to represent a model. Instead, agencies make a percentage of the model's gross income.

Some agencies require the model to maintain a minimum productivity in order to maintain representation with the agency.

For print work, this is usually in the range of 15–25 percent; for television and motion pictures, it is usually about 10 percent.

In order for you to achieve your goals and become successful in your career, it is necessary for you to incur expenses for things involved in your promotion (comp cards, shipping expenses, etc.). You will be responsible for the expenses, and your agent will deduct them from your account and future income. The agent should provide you with a rate sheet itemizing the various expenses so that you know approximately what they will be. Be aware that your agency is always promoting you, so there will be basic

expenses incurred for your promotion even when you are not in town or available to work (but these will be less than the usual amount).

What is the difference between an agent and a personal manager?
An agent's job is to negotiate contracts, market you, and take care of financial responsibility concerning clients. A personal manager is like a mother/consultant. Their responsibility is to groom you and market you to various agents and casting directors, but they do not deal with the clients directly.

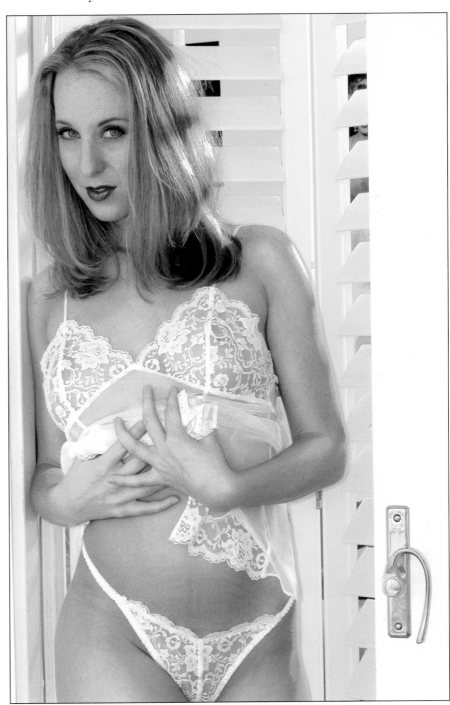

Don't give your phone number to just anyone who says they are an agent, and be especially wary of those who say they can make you a star.

Does signing with an agency mean that I will get jobs?

An agency doesn't get you jobs; it promotes you and tries to get you auditions and opportunities. You need an agent to assist you, but there is no guarantee that simply signing with an agency will make you a star—even a little one! However, freelancing is not recommended. An agent is a powerful wall between you and those who would take advantage of you. Young models especially need a good "mother"-type agent.

Who is responsible for getting me jobs?

Getting work is a combined effort by the agent and the model. The biggest mistake that beginning models make is to sit back and do nothing after they have an agent. The agent will continually market you to their clients, but the model must also take an aggressive role in his/her own marketing. After you have a job, all pertinent details and financial considerations must be negotiated by your agent.

What are castings?

Castings are opportunities for clients to meet and see you face to face. They are essential to your success as a model, because they allow you to meet new clients and begin to build a relationship with them.

A model should be courteous and professional at all times; if the client likes working with her, they may give her additional jobs in the future.

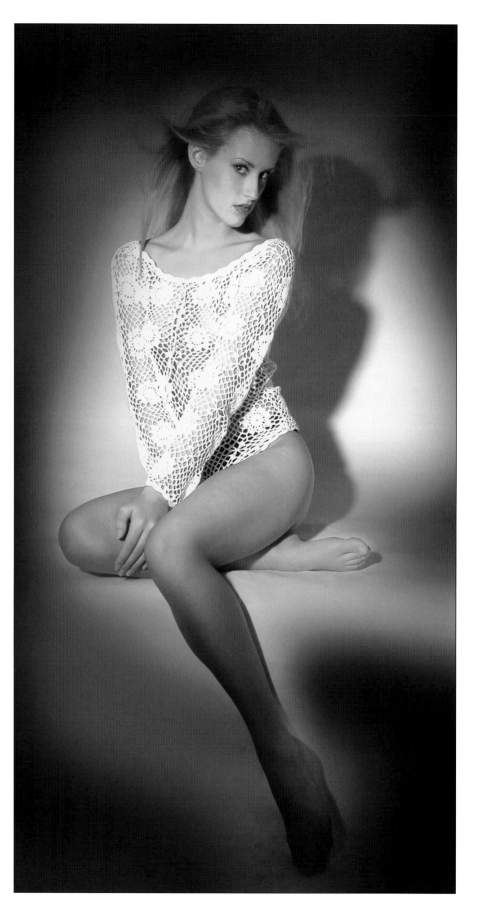

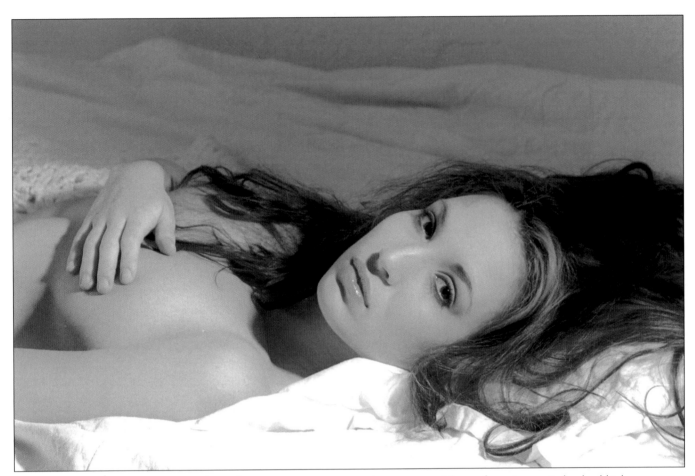

If a model is uncomfortable going to a shoot alone, or are going into an unknown or possibly unsafe environment, she should take an agency representative or female friend with her.

Castings should not be taken lightly—you should get there on time, look and act professional, and leave the client with a positive impression of you. If you are not able to make a confirmed casting or are running late, immediately call the agency to alert them so they can notify the client and attempt to reschedule (depending on the client's availability).

How do I find out I have a job?

When time permits, the agency will usually e-mail or fax you the details of your schedule so that everything is very clear (e-mail has become the more popular of these two methods). For last-minute jobs, you will need to call your agent to get the details. Having a cellular phone is useful and will pay for itself by allowing your agent to reach you in case of urgent requests or jobs.

Who determines how much I get paid for a job?

The agent will establish the rates according to the client's budget or the rate established by the agency. While on a casting or a job, never discuss rates or agree to anything that was not previously discussed. That is your agency's area of expertise, so leave that to them.

On a photo shoot, what is the responsibility of the model?

You must arrive at your job on time and bring with you a voucher for the client's signature. This must document exactly what your job included and the time you spent doing it. You must also have the client sign your voucher agreeing to the work you have completed. If you do not inform the agency of any overtime or extra work you did, then they will not be able to bill the client and get you the money.

During the shoot, the model's responsibility is to try to communicate the feeling or style that the client is trying to portray in their product. A model is responsible for posing and for portraying the attitude of the client's vision.

Be courteous and professional at all times; if the client likes working with you, they may give you additional jobs in the future. This repeat work is the key to your success and wealth in the industry.

What do I need to take with me on a job?

First of all, leave your boyfriend or husband at home. You don't go to work with them, and they shouldn't go to work with you. If you are uncomfortable going alone, or are going into an unknown or possibly unsafe environment, take an agency representative or female friend with you.

You need to take your portfolio and a complete model's bag (see below). At the end of the shoot, be sure to leave behind a comp card or zed card so the client or photographer can get in touch with you for future jobs. Also, take your agent's phone number, the client's or contact-person's phone number, and a voucher (see page 111).

To the right is a short list of what a model's bag used by a woman usually contains—and it may help you to plan your own kit, so you'll have on hand everything that you can expect to need. This list can obviously be customized to suit your individual needs, or to create a model's bag to be used by a male or child model.

FACING PAGE—It is very important that a model does not sign anything other than her voucher unless instructed to do so by her agent.

MODEL'S BAG

Makeup kit	Nylons	Safety pins
Mascara	(nude and black)	Panty liners
(brown and/or black)	Masking tape	Washcloth
	Binder clips	Toilet tissue
False eyelashes (two different lengths)	Hairpins	Facial tissue
Concealer	Toothbrush	Aspirin
Foundation	Toothpaste	(or other over-the-counter analgesic)
Lipstick (three shades)	Baby wipes	Penlight/flashlight
Blush	Hairbrush	Scissors
Eyeshadows	Hair bands	Small first-aid kit
(several colors)	Sunscreen	Razors
Translucent powder	Sunglasses	Shaving cream
Makeup sponges	Bottled water	Model portfolio
Makeup brushes	Towel	Model cards
Cotton swabs	Tampons	
Cotton balls	Dress shields	
Makeup remover	Lint brush	
Tweezers	Dress hood or	
Eye drops	pillow case	
	Spray bottle	

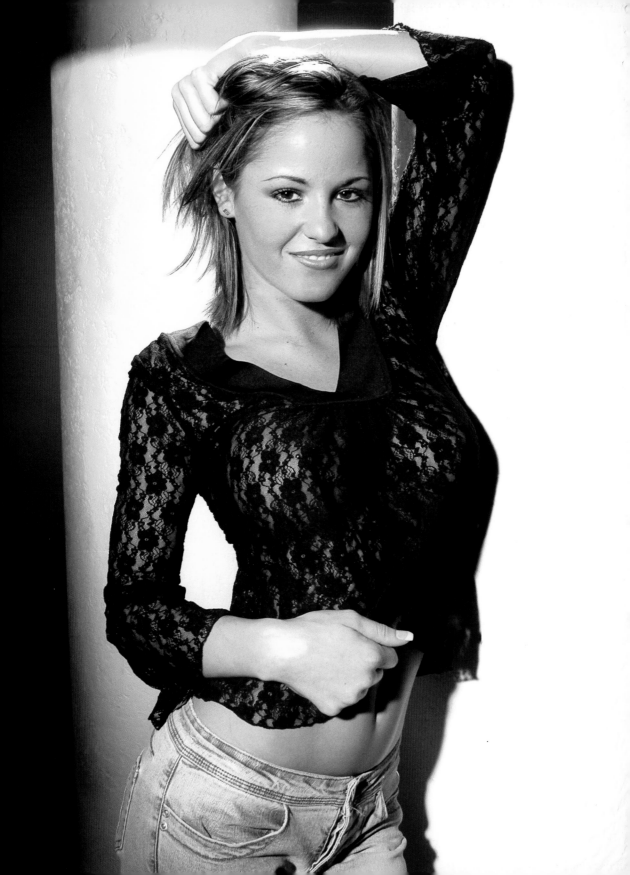

What if there are problems on the shoot?

If at any time something is occurring that you feel is not what was previously negotiated or expected, then immediately call the agency for clarification and resolution (and ask the client to do the same). It is very important that you do not sign anything other than your voucher unless instructed to do so by your agent. Never give out your home telephone

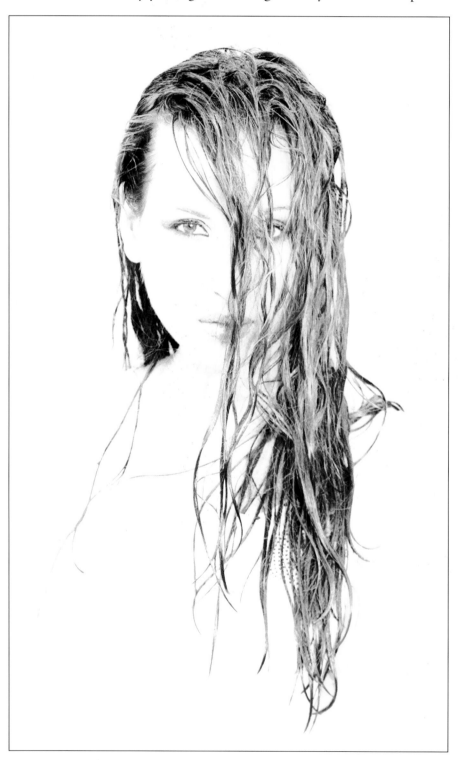

If a model approaches the industry with her feet on the ground and an eye on her pocketbook, she can have some very positive experiences! There are times when it is exciting, fun, and even very glamorous.

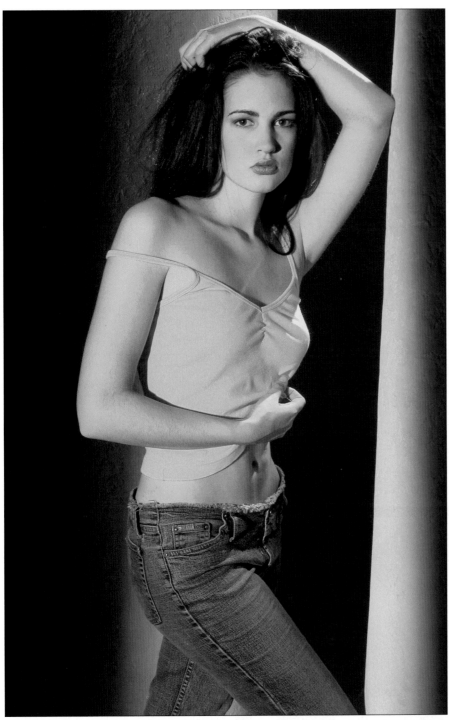

A portfolio is never complete—it is always a work in progress. A model should constantly be updating her book with new photos and tear sheets.

number or address to a client. Instead, ask them to call your agent, who can get in touch with you or forward information to you.

■ ACCOUNTING ISSUES

What are vouchers?

Most clients will not process an agency's invoice without having a completed, signed, and dated voucher from the model. In order to ensure prompt payment to you, it is important that you submit your model voucher as soon as you complete each job. If you cannot hand in your voucher personally, then fax, mail, or e-mail it to your agency with a cover sheet noting that it should be directed to the accounting department.

Can I get an advance?

As a standard policy, most agencies do not pay advances on bookings. Models get paid when the clients pay. Payments for jobs without completed, signed, and dated vouchers will *never* be advanced.

How soon will I get paid?

Normally, models will be paid within five working days of the receipt of payment from the client or 45 days from date of the completion of the job—whichever comes first.

10. Kids in the Biz

by Loa Andersen

■ LIKES

Parents often ask what I look for when casting a child. My answer is always the same—I look for the following five qualities:

The Look. The child must have the look the client is seeking— be it the red-haired, freckle-faced five-year-old, or the cherubic angel with the mischievous smile.

The Ability to Follow Directions. This is critical both for television commercials and print. Depending upon the age, I

Cody

Photo by BillyPegram.com

Here, a sequence of images was combined into a zed card to promote the boy's modeling career.

To succeed in modeling, a child needs to have an outgoing personality and be able to follow instructions.

will often ask the child to do three to four separate actions in sequence as a test. I watch for both the ability to follow the directions and the willingness to do so.

Outgoing Personality. A child cannot be shy in this industry. The child must be comfortable interacting with strangers. For example, if a child is to be filmed with "grandmother," the child must be able to pretend to love the older woman and react to her—even though it is quite probable that they have never met before.

Successful child models should have energy and a sense of spontaneous excitement.

The Ability to Focus Energy. Most children have energy; being able to focus it on a given task is a bonus.

Naturalness. The child must not be overtrained. Too often, we see children who have lost all spontaneous excitement, simply due to too much training by adults. As a result, their actions on-camera are stilted, stylized, and predictable—and generally far too mature for their age.

■ DISLIKES

When asked what I don't like to see, I could list many more items than I have included here. However, here are a few of my pet peeves:

Makeup on Small Children. I want to see a fresh-faced, natural child; I don't want to see a mini version of an adult. The same goes for fancy clothes—don't let the clothes overpower the child. After all, I'm not casting the outfit, I'm looking for a *child*. Clean play clothes are all that is necessary.

Overstyled, Sprayed Hair. Again, the child should look his or her age.

Robotic or Exaggerated Behavior. This is the result of over-

training. When a child acts this way, my interest in him wanes immediately.

Stage Parents. The child should be dragging the parents to an audition, not the other way around.

Inappropriate Pictures. This topic deserves it own paragraph. Please see the next page.

Clean, simple headshots are important for all models (above). Showing any special skills or abilities can also be useful (right).

■ PHOTOGRAPHS

Far too often, parents are encouraged to spend far too much money on photographs. Generally, these are not needed. For very young children and babies, only snapshots are necessary. However, make sure they are current snapshots. Little children's faces and bodies grow and change so quickly, it does not make sense to develop a full portfolio for them.

For a young child, one or two good headshots and one full body shot is sufficient. These should not be glamour shots, but shots that show the child in a natural setting. Again, guard against making the child look overdressed or too styled.

Unfortunately, I have seen photos deliberately taken to make little ones look sexy. This is highly inappropriate and will not help in obtaining work for the child. The key words for child photography are fresh, natural, spontaneous, and childlike!

BELOW AND FACING PAGE—The key words for child photography are fresh, natural, spontaneous, and childlike!

Bear in mind that there is an enormous difference between photography geared to getting a child into television commercials and modeling and photography taken for the pageant system. For commercial work, the agents want a fresh and natural look where the outfits are downplayed, as I have mentioned previously. Pageant photography often is much more glamorous in nature, and the outfits, makeup, and hairstyles are intensified. There has been, in recent years, a slight move away from this typical pageant photography toward a more commercial style, but this trend varies from place to place and pageant to pageant. For photographers working with a prospective model, it is best to ask the parents exactly what they are seeking and, if possible, have them show an example of a photo they like.

Parents often ask photographers how to get their kids into modeling. I generally suggest that they locate a good agency. Remind parents never to pay an agent up-front fees. While it is common to be asked to pay for

some promotional materials, such as photos and cards, it is *not* common to be charged an initial "sign-up" or "registration" fee! An agent should only receive payment in the form of a percentage of the fees the child receives for a booking.

For babies, I suggest the parents get the names of all the agents in their area who represent children and send them an updated snapshot about every six weeks. Most agencies keep baby files. For the older children, agents usually will sign only the children they wish to represent. They will then advise the parents of the photos they want. To audition for an agent, a child does not need a full portfolio. Only a couple of up-to-date, really good headshots and one full body shot are necessary.

■ IN CLOSING

Shooting images for a child who is getting into modeling can be either very rewarding or extremely challenging. The determining factor is how the photographer prepares the child—and the parents—for the shoot. By taking into account the information presented here, you should be well on your way!

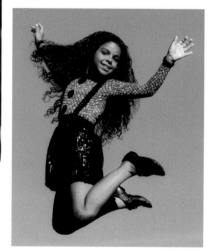

Rielle
555-434-0101

Date of Birth: May 30 1992

Hair: Brown

Eyes: Dark Brown

Here, the images shown on the previous two pages were combined with additional photos to create the model's zed card.

In Closing

The career of a fashion model is heavily dependent on the participation of the photographers she works with. Many supermodels even credit their relationship with a particular photographer as being critical to their career.

Most fashion photographers have a few established models they use frequently. This relationship has many advantages when working under stressful or difficult conditions. When hiring models for a major account I almost always hire people that I have worked with in the past. I know that they are dependable, I know their strengths and weaknesses, and they know how I work and understand my expectations. So, my final words of wisdom are to find a few models that you love to work with and help them with their careers. As a photographer, you will benefit by becoming a more established and experienced professional.

While most model photographers will never gain fame or fortune, most will have creative experiences and opportunities that the majority of people in today's workplace only dream about. Approach model photography as a learning experience every day, and thank yourself for choosing a job in which the immeasurable rewards include the opportunity to have fun and be creative.

My final words of wisdom are to find a few models that you love to work with and help them with their careers.

FOR MORE . . .

For more information on Billy Pegram or to see more of his images, please visit www.billypegram.com or www.pegramstudios.com.

Index

OTHER BOOKS FROM

Amherst Media®

THE BEST OF PHOTOGRAPHIC LIGHTING

Bill Hurter

Top professionals reveal the secrets behind their successful strategies for studio, location, and outdoor lighting. Packed with tips for portraits, still lifes, and more. $34.95 list, 8½x11, 128p, 150 color photos, index, order no. 1808.

LIGHTING TECHNIQUES FOR

FASHION AND GLAMOUR PHOTOGRAPHY

Stephen A. Dantzig, PsyD.

In fashion and glamour photography, light is the key to producing images with impact. With these techniques, you'll be primed for success! $29.95 list, 8½x11, 128p, over 200 color images, index, order no. 1795.

WEDDING AND PORTRAIT PHOTOGRAPHERS' LEGAL HANDBOOK

N. Phillips and C. Nudo, Esq.

Don't leave yourself exposed! Sample forms and practical discussions help you protect yourself and your business. $29.95 list, 8½x11, 128p, 25 sample forms, index, order no. 1796.

CORRECTIVE LIGHTING, POSING & RETOUCHING FOR

DIGITAL PORTRAIT PHOTOGRAPHERS, 2nd Ed.

Jeff Smith

Learn to make every client look his or her best by using lighting and posing to conceal real or imagined flaws—from baldness, to acne, to figure flaws. $34.95 list, 8½x11, 120p, 150 color photos, order no. 1711.

PORTRAIT PHOTOGRAPHER'S HANDBOOK, 2nd Ed.

Bill Hurter

Bill Hurter has compiled a step-by-step guide to portraiture that easily leads the reader through all phases of portrait photography. This book will be an asset to experienced photographers and beginners alike. $29.95 list, 8½x11, 128p, 175 color photos, order no. 1708.

TRADITIONAL PHOTO-GRAPHIC EFFECTS WITH ADOBE® PHOTOSHOP®, 2nd Ed.

Michelle Perkins and Paul Grant

Use Photoshop to enhance your photos with handcoloring, vignettes, soft focus, and much more. Step-by-step instructions are included for each technique for easy learning. $29.95 list, 8½x11, 128p, 150 color images, order no. 1721.

MASTER POSING GUIDE FOR PORTRAIT PHOTOGRAPHERS

J. D. Wacker

Learn the techniques you need to pose single portrait subjects, couples, and groups for studio or location portraits. Includes techniques for photographing weddings, teams, children, special events, and much more. $29.95 list, 8½x11, 128p, 80 photos, order no. 1722.

PROFESSIONAL TECHNIQUES FOR

DIGITAL WEDDING PHOTOGRAPHY, 2nd Ed.

Jeff Hawkins and Kathleen Hawkins

From selecting equipment, to marketing, to building a digital workflow, this book teaches how to make digital work for you. $29.95 list, 8½x11, 128p, 85 color images, order no. 1735.

GROUP PORTRAIT PHOTOGRAPHY HANDBOOK, 2nd Ed.

Bill Hurter

Featuring over 100 images by top photographers, this book offers practical techniques for composing, lighting, and posing group portraits—whether in the studio or on location. $34.95 list, 8½x11, 128p, 120 color photos, order no. 1740.

LIGHTING AND EXPOSURE TECHNIQUES FOR

OUTDOOR AND LOCATION PORTRAIT PHOTOGRAPHY

J. J. Allen

Meet the challenges of changing light and complex settings with techniques that help you achieve great images every time. $29.95 list, 8½x11, 128p, 150 color photos, order no. 1741.

THE ART OF BLACK & WHITE PORTRAIT PHOTOGRAPHY

Oscar Lozoya

Learn how master photographer Oscar Lozoya uses unique sets and engaging poses to create black & white portraits that are infused with drama. Includes lighting strategies, special shooting techniques, and more. $29.95 list, 8½x11, 128p, 100 duotone photos, order no. 1746.

THE BEST OF WEDDING PHOTOGRAPHY, 2nd Ed.

Bill Hurter

Learn how the top wedding photographers in the industry transform special moments into lasting romantic treasures with the posing, lighting, album design, and customer service pointers found in this book. $34.95 list, 8½x11, 128p, 150 color photos, order no. 1747.

THE BEST OF CHILDREN'S PORTRAIT PHOTOGRAPHY

Bill Hurter

Rangefinder editor Bill Hurter draws upon the experience and work of top professional photographers, uncovering the creative and technical skills they use to create their magical portraits of these young subejcts. $29.95 list, 8½x11, 128p, 150 color photos, order no. 1752.

PROFESSIONAL PHOTOGRAPHER'S GUIDE TO
SUCCESS IN PRINT COMPETITION

Patrick Rice

Learn from PPA and WPPI judges how you can improve your print presentations and increase your scores. $29.95 list, 8½x11, 128p, 100 color photos, index, order no. 1754.

PHOTOGRAPHER'S GUIDE TO
WEDDING ALBUM DESIGN AND SALES

Bob Coates

Enhance your income and creativity with these techniques from top wedding photographers. $29.95 list, 8½x11, 128p, 150 color photos, index, order no. 1757.

THE BEST OF PORTRAIT PHOTOGRAPHY

Bill Hurter

View outstanding images from top professionals and learn how they create their masterful images. Includes techniques for classic and contemporary portraits. $29.95 list, 8½x11, 128p, 200 color photos, index, order no. 1760.

THE BEST OF TEEN AND SENIOR PORTRAIT PHOTOGRAPHY

Bill Hurter

Learn how top professionals create stunning images that capture the personality of their teen and senior subjects. $29.95 list, 8½x11, 128p, 150 color photos, index, order no. 1766.

PROFESSIONAL STRATEGIES AND TECHNIQUES FOR DIGITAL PHOTOGRAPHERS

Bob Coates

Learn how professionals—from portrait artists to commercial specialists—enhance their images with digital techniques. $29.95 list, 8½x11, 128p, 130 color photos, index, order no. 1772.

LIGHTING TECHNIQUES FOR
LOW KEY PORTRAIT PHOTOGRAPHY

Norman Phillips

Learn to create the dark tones and dramatic lighting that typify this classic portrait style. $29.95 list, 8½x11, 128p, 100 color photos, index, order no. 1773.

THE BEST OF WEDDING PHOTOJOURNALISM

Bill Hurter

Learn how top professionals capture these fleeting moments of laughter, tears, and romance. Features images from over twenty renowned wedding photographers. $29.95 list, 8½x11, 128p, 150 color photos, index, order no. 1774.

THE DIGITAL DARKROOM GUIDE WITH ADOBE® PHOTOSHOP®

Maurice Hamilton

Bring the skills and control of the photographic darkroom to your desktop with this complete manual. $29.95 list, 8½x11, 128p, 140 color images, index, order no. 1775.

COLOR CORRECTION AND ENHANCEMENT WITH ADOBE® PHOTOSHOP®

Michelle Perkins

Master precision color correction and artistic color enhancement techniques for scanned and digital photos. $29.95 list, 8½x11, 128p, 300 color images, index, order no. 1776.

BIG BUCKS SELLING YOUR PHOTOGRAPHY, 3rd Ed.

Cliff Hollenbeck

Build a new business or revitalize an existing one with the comprehensive tips in this popular book. Includes twenty forms you can use for invoicing clients, collections, follow-ups, and more. $17.95 list, 8½x11, 144p, resources, business forms, order no. 1177.

PORTRAIT PHOTOGRAPHY

THE ART OF SEEING LIGHT

Don Blair with Peter Skinner

Learn to harness the best light both in studio and on location, and get the secrets behind the magical portraiture captured by this award-winning, seasoned pro. $29.95 list, 8½x11, 128p, 100 color photos, index, order no. 1783.

PLUG-INS FOR ADOBE® PHOTOSHOP®

A GUIDE FOR PHOTOGRAPHERS

Jack and Sue Drafahl

Supercharge your creativity and mastery over your photography with Photoshop and the tools outlined in this book. $29.95 list, 8½x11, 128p, 175 color photos, index, order no. 1781.

POWER MARKETING FOR WEDDING AND PORTRAIT PHOTOGRAPHERS

Mitche Graf

Set your business apart and create clients for life with this comprehensive guide to achieving your professional goals. $29.95 list, 8½x11, 128p, 100 color images, index, order no. 1788.

BEGINNER'S GUIDE TO ADOBE® PHOTOSHOP® ELEMENTS®

Michelle Perkins

Packed with easy lessons for improving virtually every aspect of your images—from color balance, to creative effects, and more. $29.95 list, 8½x11, 128p, 300 color images, index, order no. 1790.

BEGINNER'S GUIDE TO PHOTOGRAPHIC LIGHTING

Don Marr

Create high-impact photographs of any subject with Marr's simple techniques. From edgy and dynamic to subdued and natural, this book will show you how to get the myriad effects you're after. $29.95 list, 8½x11, 128p, 150 color photos, index, order no. 1785.

POSING FOR PORTRAIT PHOTOGRAPHY

A HEAD-TO-TOE GUIDE

Jeff Smith

Author Jeff Smith teaches surefire techniques for fine-tuning every aspect of the pose for the most flattering results. $29.95 list, 8½x11, 128p, 150 color photos, index, order no. 1786.

THE PORTRAIT PHOTOGRAPHER'S GUIDE TO POSING

Bill Hurter

Posing can make or break an image. Now you can get the posing tips and techniques that have propelled the finest portrait photographers in the industry to the top. $29.95 list, 8½x11, 128p, 200 color photos, index, order no. 1779.

MASTER LIGHTING GUIDE

FOR PORTRAIT PHOTOGRAPHERS

Christopher Grey

Efficiently light executive and model portraits, high and low key images, and more. Master traditional lighting styles and use creative modifications that will maximize your results. $29.95 list, 8½x11, 128p, 300 color photos, index, order no. 1778.

PROFESSIONAL DIGITAL IMAGING FOR WEDDING AND PORTRAIT PHOTOGRAPHERS

Patrick Rice

Build your business and enhance your creativity with practical strategies for making digital work for you. $29.95 list, 8½x11, 128p, 200 color photos, index, order no. 1780.

STUDIO LIGHTING

A PRIMER FOR PHOTOGRAPHERS

Lou Jacobs Jr.

Get started in studio lighting. Jacobs outlines equipment needs, terminology, lighting setups and much more, showing you how to create top-notch portraits and still lifes. $29.95 list, 8½x11, 128p, 190 color photos index, order no. 1787.

CLASSIC PORTRAIT PHOTOGRAPHY

William S. McIntosh

Learn how to create portraits that truly stand the test of time. Master photographer Bill McIntosh discusses some of his best images, giving you an inside look at his timeless style. $29.95 list, 8½x11, 128p, 100 color photos, index, order no. 1784.

THE MASTER GUIDE TO DIGITAL SLR CAMERAS

Stan Sholik and Ron Eggers

What makes a digital SLR the right one for you? What features are available? What should you look out for? These questions and more are answered in this helpful guide. $29.95 list, 8½x11, 128p, 180 color photos, index, order no. 1791.

DIGITAL INFRARED PHOTOGRAPHY

Patrick Rice

The dramatic look of infrared photography has long made it popular—but with digital it's actually *easy* too! Add digital IR to your repertoire with this comprehensive book. $29.95 list, 8½x11, 128p, 100 b&w and color photos, index, order no. 1792.

THE BEST OF DIGITAL WEDDING PHOTOGRAPHY

Bill Hurter

Explore the groundbreaking images and techniques that are shaping the future of wedding photography. Includes dazzling photos from over 35 top photographers. $29.95 list, 8½x11, 128p, 175 color photos, index, order no. 1793.

PROFITABLE PORTRAITS

THE PHOTOGRAPHER'S GUIDE TO CREATING PORTRAITS THAT SELL

Jeff Smith

Learn how to design images that are precisely tailored to your clients' tastes—portraits that will practically sell themselves! $29.95 list, 8½x11, 128p, 100 color photos, index, order no. 1797.

PROFESSIONAL TECHNIQUES FOR

BLACK & WHITE DIGITAL PHOTOGRAPHY

Patrick Rice

Digital makes it easier than ever to create black & white images. With these techniques, you'll learn to achieve dazzling results! $29.95 list, 8½x11, 128p, 100 color photos, index, order no. 1798.

DIGITAL PORTRAIT PHOTOGRAPHY OF

TEENS AND SENIORS

Patrick Rice

Learn the techniques top professionals use to shoot and sell portraits of teens and high-school seniors! Includes tips for every phase of the digital process. $34.95 list, 8½x11, 128p, 200 color photos, index, order no. 1803.

MARKETING & SELLING TECHNIQUES

FOR DIGITAL PORTRAIT PHOTOGRAPHERS

Kathleen Hawkins

Great portraits aren't enough to ensure the success of your business! Learn how to attract clients and boost your sales. $34.95 list, 8½x11, 128p, 150 color photos, index, order no. 1804.

ARTISTIC TECHNIQUES WITH ADOBE® PHOTOSHOP® AND COREL® PAINTER®

Deborah Lynn Ferro

Flex your creative skills and learn how to transform photographs into fine-art masterpieces. Step-by-step techniques make it easy! $34.95 list, 8½x11, 128p, 200 color images, index, order no. 1806.

MASTER GUIDE FOR

UNDERWATER DIGITAL PHOTOGRAPHY

Jack and Sue Drafahl

Make the most of digital! Jack and Sue Drafahl take you from equipment selection to underwater shooting techniques. $34.95 list, 8½x11, 128p, 250 color images, index, order no. 1807.

DIGITAL PHOTOGRAPHY BOOT CAMP

Kevin Kubota

Kevin Kubota's popular workshop is now a book! A down-and-dirty, step-by-step course in building a professional photography workflow and creating digital images that sell! $34.95 list, 8½x11, 128p, 250 color images, index, order no. 1809.

PROFESSIONAL POSING TECHNIQUES FOR WEDDING AND

PORTRAIT PHOTOGRAPHERS

Norman Phillips

Master the techniques you need to pose subjects successfully—whether you are working with men, women, children, or groups. $34.95 list, 8½x11, 128p, 260 color photos, index, order no. 1810.

HOW TO START AND OPERATE A

DIGITAL PORTRAIT PHOTOGRAPHY STUDIO

Lou Jacobs Jr.

Learn how to build a successful digital portrait photography business—or breathe new life into an existing studio. $39.95 list, 6x9, 224p, 150 color images, index, order no. 1811.

BLACK & WHITE PHOTOGRAPHY

TECHNIQUES WITH ADOBE® PHOTOSHOP®

Maurice Hamilton

Become a master of the black & white digital darkroom! Covers all the skills required to perfect your black & white images and produce dazzling fine-art prints. $34.95 list, 8½x11, 128p, 150 color/b&w images, index, order no. 1813.

NIGHT AND LOW-LIGHT

TECHNIQUES FOR DIGITAL PHOTOGRAPHY

Peter Cope

With even simple point-and-shoot digital cameras, you can create dazzling nighttime photos. Get started quickly with this step-by-step guide. $34.95 list, 8½x11, 128p, 100 color photos, index, order no. 1814.

MASTER COMPOSITION

GUIDE FOR DIGITAL PHOTOGRAPHERS

Ernst Wildi

Composition can truly make or break an image. Master photographer Ernst Wildi shows you how to analyze your scene or subject and produce the best-possible image. $34.95 list, 8½x11, 128p, 150 color photos, index, order no. 1817.

SUCCESS IN PORTRAIT PHOTOGRAPHY

Jeff Smith

Many photographers realize too late that camera skills alone do not ensure success. This book will teach photographers how to run savvy marketing campaigns, attract clients, and provide top-notch customer service. $29.95 list, 8½x11, 128p, 100 color photos, order no. 1748.

WEDDING PHOTOGRAPHY

CREATIVE TECHNIQUES FOR LIGHTING, POSING, AND MARKETING, 3rd Ed.

Rick Ferro

Creative techniques for lighting and posing wedding portraits that will set your work apart from the competition. Covers every phase of wedding photography. $29.95 list, 8½x11, 128p, 125 color photos, index, order no. 1649.

WEB SITE DESIGN FOR PROFESSIONAL PHOTOGRAPHERS

Paul Rose and Jean Holland-Rose

Learn how to design, maintain, and update your own photography web site—attracting new clients and boosting your sales. $29.95 list, 8½x11, 128p, 100 color images, index, order no. 1756.

POSING AND LIGHTING TECHNIQUES FOR STUDIO PHOTOGRAPHERS

J. J. Allen

Master the skills you need to create beautiful lighting for portraits. Posing techniques for flattering, classic images help turn every portrait into a work of art. $29.95 list, 8½x11, 120p, 125 color photos, order no. 1697.

THE ART AND BUSINESS OF

HIGH SCHOOL SENIOR PORTRAIT PHOTOGRAPHY

Ellie Vayo

Learn the techniques that have made Ellie Vayo's studio one of the most profitable senior portrait businesses in the U.S. $29.95 list, 8½x11, 128p, 100 color photos, order no. 1743.

BEGINNER'S GUIDE TO ADOBE® PHOTOSHOP® ELEMENTS®

Michelle Perkins

Packed with easy lessons for improving virtually every aspect of your images—from color balance, to creative effects, and more. $29.95 list, 8½x11, 128p, 300 color images, index, order no. 1790.

MORE PHOTO BOOKS ARE AVAILABLE

Amherst Media®

PO BOX 586
BUFFALO, NY 14226 USA

INDIVIDUALS: If possible, purchase books from an Amherst Media retailer. Contact us for the dealer nearest you, or visit our web site and use our dealer locater. To order direct, visit our web site, or send a check/money order with a note listing the books you want and your shipping address. All major credit cards are also accepted. For domestic and international shipping rates, please visit our web site or contact us at the numbers listed below. New York state residents add 8% sales tax.

DEALERS, DISTRIBUTORS & COLLEGES: Write, call, or fax to place orders. For price information, contact Amherst Media or an Amherst Media sales representative. Net 30 days.

(800)622-3278 or (716)874-4450
FAX: (716)874-4508

All prices, publication dates, and specifications are subject to change without notice. Prices are in U.S. dollars. Payment in U.S. funds only.

WWW.AMHERSTMEDIA.COM

FOR A COMPLETE CATALOG OF BOOKS AND ADDITIONAL INFORMATION